YORK PLACES OF LEARNING

THROUGH TIME

Paul Chrystal & Simon Crossley

AMBERLEY PUBLISHING

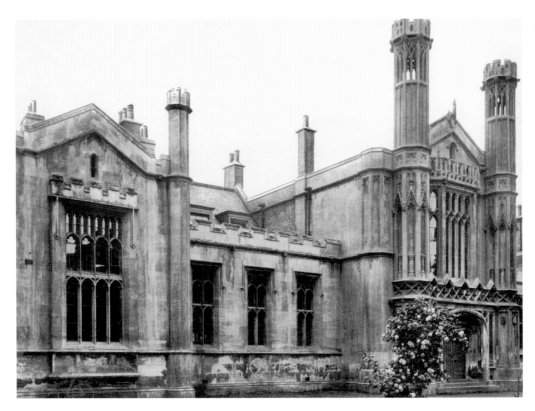

St Peter's School, founded in AD 627.

First published 2011

Amberley Publishing
The Hill, Stroud
Gloucestershire, GL5 4EP

www.amberleybooks.com

Copyright © Paul Chrystal & Simon Crossley 2011

The right of Paul Chrystal & Simon Crossley to be
identified as the Authors of this work has been
asserted in accordance with the Copyrights, Designs
and Patents Act 1988.

ISBN 978-1-4456-0612-5

British Library Cataloguing in Publication Data.
A catalogue record for this book is available from
the British Library.

Typeset in 9.5pt on 12pt Celeste.
Typesetting by Amberley Publishing.
Printed in the UK.

Introduction

York is rightly world famous for its Minster, its medieval streets and walls, its railways and the confectionery industry. But none of these came about independently – they are all underpinned by another, less obvious, facet of York's heritage. The city has always been an important seat of learning and culture, from the establishment of Alcuin's library in the eighth century to the twentieth and twenty-first century development of the two universities. *York Places of Learning Through Time* also covers the city's unique and world-famous museums, galleries and libraries, a number of which were founded by august and nationally influential York societies.

This unique new book explores York's role as a vital centre of learning and culture by means of nearly 200 photographs depicting its history and development and, in most cases, describing how it persists and continue to thrive today. These images are complemented by short but informative captions that explain and explore this lesser-known aspect of York's history. Obviously, the scope of the book is determined by the images available and for this reason the pictures and captions provide a selective rather than a continuous history. Nevertheless, most of the important facts are here and the reader will finish the book with a good understanding of York's educational and cultural past and present.

The two universities have fine reputations in their particular fields, with the University of York now blessed with a medical school and science research facilities that are world-class. York can boast some of the country's outstanding state and independent schools, including the innovative Joseph Rowntree School and one of the nation's oldest, St Peter's School, Guy Fawkes' *alma mater*. The city's association with Quakerism brought about the Mount School and Bootham, as well as that fine example of enlightened industrial relations, the Joseph Rowntree Memorial Library. Other prestigious collections are held in the foremost ecclesiastic library in the land, the Minster Library, the Borthwick Institute for Archives, and Explore York, with its unsurpassed local history collection.

Museums abound, and they tend to be the country's best in their respective fields: the National Railway Museum, the Jorvik Viking Centre, the Yorkshire Museum and the Castle Museum, which is one of the finest presentations of a region's heritage existing in Britain today. The Bar Convent is particularly special because it was an important religious and secular school and is now an intriguing and unique museum. Add to this York Art Gallery, the theatres and the many other buildings that exude history and enjoy a reputation for learning or

teaching in one form or another: St William's College, Bedern Hall, Fairfax House, Gray's Court, the Observatory and Barley Hall, to name a handful. Finally, York is home to two influential scientific societies: the York Medical Society and the Yorkshire Philosophical Society, which was instrumental in establishing the British Association for the Advancement of Science (now the British Science Association).

The following words and pictures reveal an overlooked but crucial aspect of York's long and fascinating history.

Paul Chrystal
July 2011

Acknowledgements

Thanks to the following for their generosity in providing images for this book – without their kindness, the book would be much diminished – Melvyn Browne; Jane Peake, Bootham School; Sarah Sheils of the Mount School (in particular for her permission to use photographs old and new originally published in her excellent *Among Friends: The Story of the Mount School, York*); Pat Chandler (for permission to use images from the St Peter's School Archive); Christine Kyriacou, York Archaeological Trust for Excavation and Research Limited (for pictures of Barley Hall and the Jorvik Viking Centre); Paul Herring, York Medical Society; Jim Spriggs and Bob Hale, Yorkshire Philosophical Society; John Maw, York St John University; Sister Christina Kenworthy-Browne, the Bar Convent; Heather Audin, Quilt Museum and Gallery; the staff of Barley Hall; Lizzie Richards, Grand Opera House; Mike Bennett and staff, Richard III Museum; Fiona Martin, York Theatre Royal; the staff of the Yorkshire Museum and the Castle Museum; La Vecchia Scuola Restaurant; Hannah Phillip (for images reproduced courtesy of Fairfax House, York Civic Trust); Jackie Logan, York Museums Trust (for pictures of the Yorkshire Museum and the Museum Gardens); Martin Dawson, York Observatory; Jacqui Sissons, Archbishop Holgate School; Maggie Wright, Joseph Rowntree School; Mary White, librarian at Search Engine, National Railway Museum.

A Note on the Authors

Paul Chrystal and Simon Crossley are the authors of the following titles in the *Through Time* series, all to be published in 2011: *Hartlepool*; *Vale of York*; *Harrogate*; *York Industries and Business*; *Redcar, Marske and Saltburn*; *In and Around York*; *Pocklington and Surrounding Villages*; *Barnard Castle and Teesdale*.

With Mark Sunderland, Paul Chrystal co-authored the following titles in the *Through Time* series in 2010: *Knaresborough*; *North York Moors*; *Tadcaster*; *Villages Around York*; *Richmond and Swaledale*; *Northallerton*.

Other forthcoming books by Paul Chrystal: *A Children's History of Harrogate and Knaresborough* (2011); *An A–Z of Knaresborough History* (revised edition, 2011); *Chocolate: The British Chocolate Industry* (2011); *York and Its Confectionery Industry* (2011); *The Rowntree Family in York* (2012); *A–Z of York History* (2012); *The Lifeboats of the North East* (2012); *Rowntree and Terry: An Illustrated History*; *Cadbury and Fry: An Illustrated History*.

For more of Simon Crossley's work, visit www.iconsoncanvas.com; to see Mark Sunderland's work, visit www.marksunderland.com.

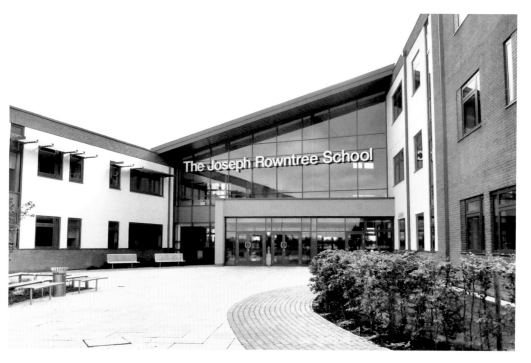

The new Joseph Rowntree School, opened in 2010.

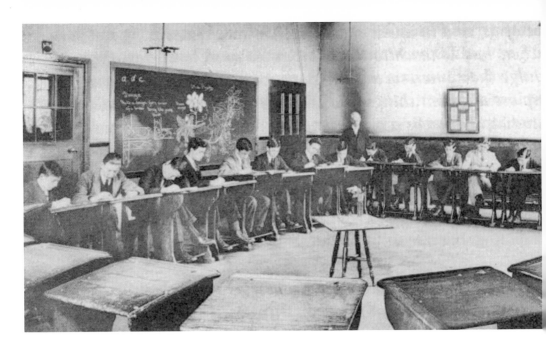

Archbishop Holgate's School

The school is, after St Peter's, the oldest in York. It was founded as Archbishop Holgate's Grammar School in 1546 by Robert Holgate, Archbishop of York, financed by capital from the Dissolution of the Monasteries. The original grammar school was in Ogleforth and was known as the Reverend Shackley's School; one of the teachers was Thomas Cooke, the optical instrument manufacturer who went on to establish T. Cooke & Sons, later Cooke, Troughton & Simms, the famous telescope manufacturers. In 1858, the school merged with the Yeoman School when it moved to Lord Mayor's Walk; it relocated again in 1963 to its present site in Badger Hill, pictured here. The older photograph shows some superb blackboard work in a 1950s art class.

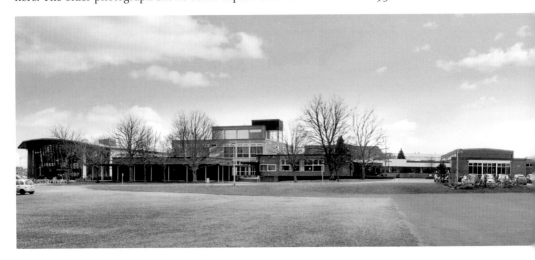

Holderness and Lambert

Chemistry teacher Albert Holderness and John Lambert, both old boys of Archbishop Holgate's, were the authors of one of the most successful school chemistry books ever published: *School Certificate Chemistry*, published in 1936. The 500,000th copy came off the press in 1962 and the book remains in print today in its sixth edition, retitled *A New Certificate Chemistry*.

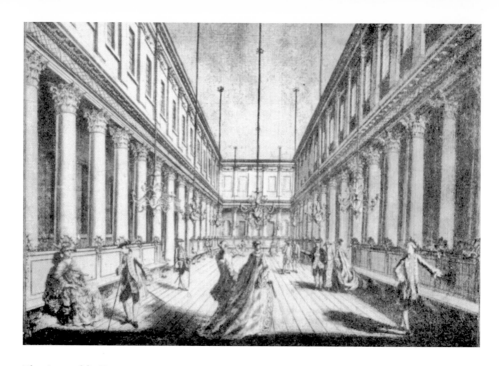

The Assembly Rooms

This magnificent 1732 building, one of the earliest neo-classical buildings in Europe, was built in the Palladian style and paid for by subscription (Lord Burlington, the architect, apparently took his design from Palladio's sixteenth-century drawing of an ancient Egyptian festival hall). Its purpose was to provide local and visiting gentry with somewhere sumptuous to play dice and cards, dance and drink tea. The building epitomised the age of elegance and helped make York the capital of north-country fashion – a northern Bath. Today the building still exudes style and one can dine among the forty-eight Corinthian pillars. The 1759 etching is by William Lindley and is part of the Evelyn Collection in the York Art Gallery.

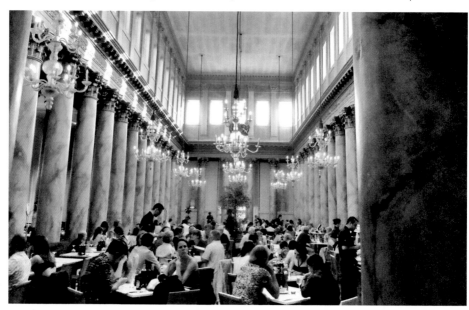

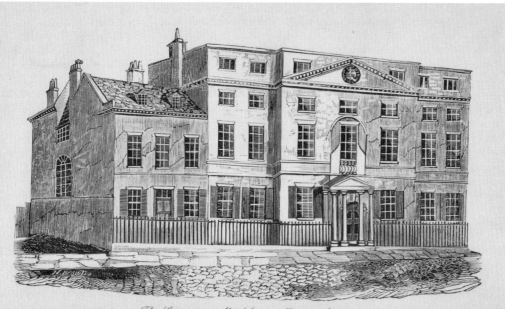

The Convent, Micklegate-Bar without.

The Bar Convent in 1790

The oldest lived-in convent in England, the Bar Convent was established as a school for Catholic girls in 1686 by Frances Bedingfield, an early member of Mary Ward's Institute, in response to Sir Thomas Gascoigne's demand: 'We must have a school for our daughters.' Sir Thomas, a local Catholic landowner, provided £450 to set up a boarding school; this was followed in 1699 by a free day school. Frances Bedingfield had been imprisoned in Ousebridge Gaol for her religious beliefs. The nuns, who still live here, belong to the Congregation of Jesus, which was founded by Mary Ward (1585–1645). The engraving shows the convent in 1790; the new picture is of the splendid entrance hall with its beautiful tiling.

9

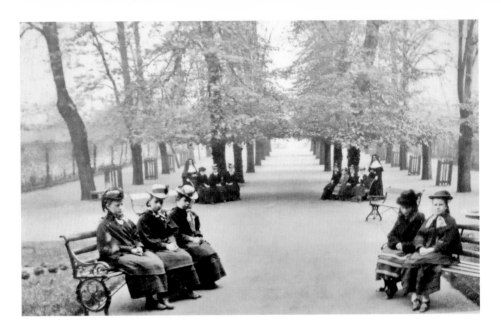

The Bar Convent in 1844

For Catholics, the seventeenth century was often a time of persecution and the Bar Convent was very much a clandestine community. Known as 'the Ladies at the Bar', the sisters wore plain grey day dresses rather than habits to avoid raising suspicion. The community suffered great poverty, persecution and imprisonment – not just for their faith but also for teaching that faith. However, it survived, and in 1727 Elizabeth Stansfield and Ann Aspinal paid off the community's debts. In the 1760s, the original house was demolished and replaced with the fine Georgian house and integral chapel that can be visited today.

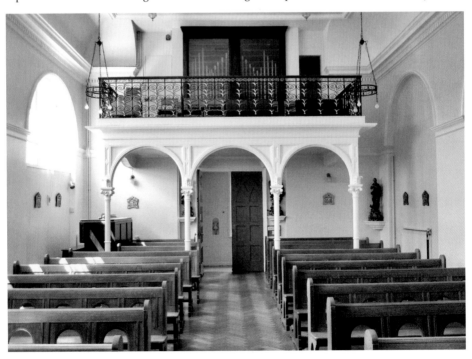

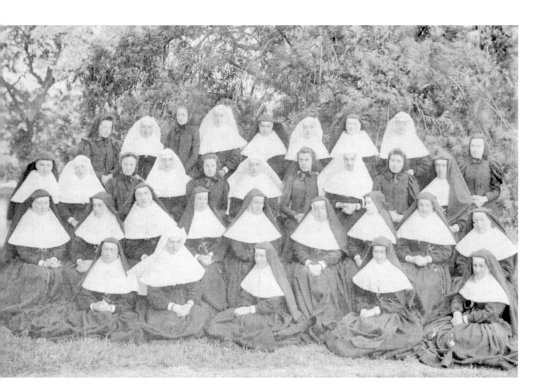

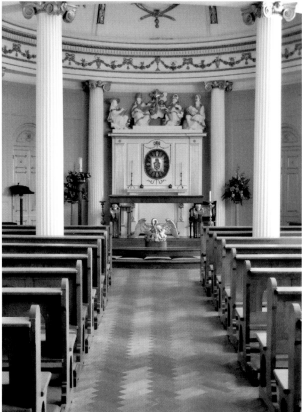

Bar Convent Community *c.* 1900
April 1769 saw the first Mass
to be held in Mother Aspinal's
beautiful new chapel, with its
magnificent, but externally
unobtrusive, neo-classical dome
concealed beneath a pitched slate
roof. Apart from the discreet
dome, the building has many
other integral features that betray
the nature of its activities. The
chapel is situated in the centre
of the building so that it cannot
be seen from the street, its plain
windows reveal nothing of its
ecclesiastical nature and there
are no fewer than eight exits
providing escape routes for the
congregation in the event of a
raid. There is also a priest hole,
which can still be seen today.

11

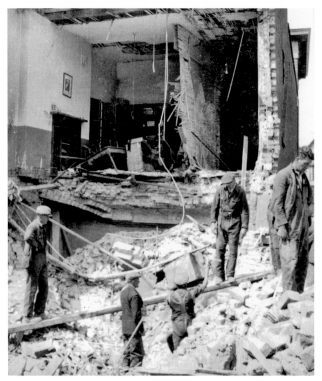

The Baedecker Raid Tragedy

Later work to the Bar Convent in 1844 by G. T. Andrews resulted in an extension that included an enlarged day school and a conspicuous cross on the pediment. In the 1860s, the open courtyard at the centre of the building was glazed over. At this time the school was known locally as 'the poor school'. The floor is graced with tiles by Maws of Coalbrookdale. During the Great War, Belgian nuns and refugee children were accommodated in the convent and the concert hall was converted into a hospital ward for wounded soldiers. Tragedy struck in the Second World War during the 1942 Baedecker raids, when the convent was bombed and five sisters were killed.

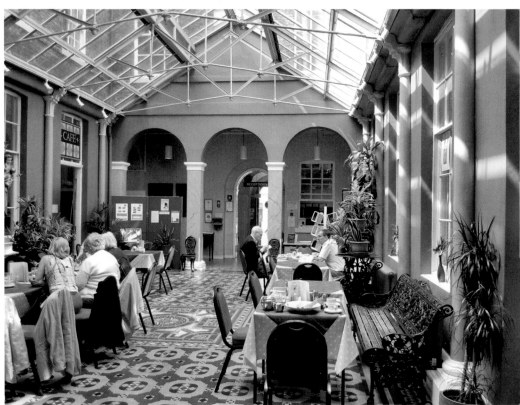

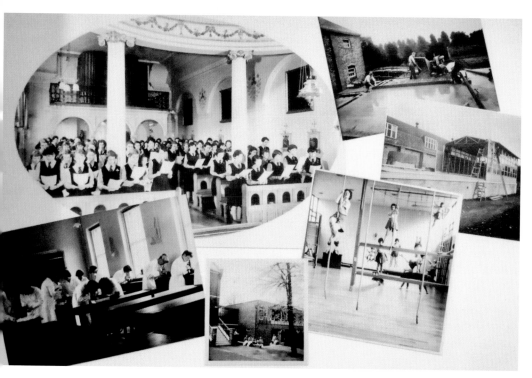

Mary Ward

The fifty pictures alongside the Bar Convent's 1987 staircase depict the life of Mary Ward. They were reproduced from seventeenth-century paintings in the Institute of Augsburg. The 2,000 or so books in the library date from between 1508 and 1850 and, unlike some library collections, they are well used and annotated. The convent also retains the preserved hand of St Margaret Clitherow. In 1977, the day school and boarding school eventually merged to become the Bar Convent Grammar School and boys were admitted for the first time; in 1985 it became part of All Saints' Roman Catholic School.

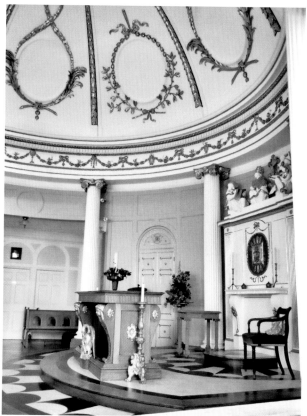

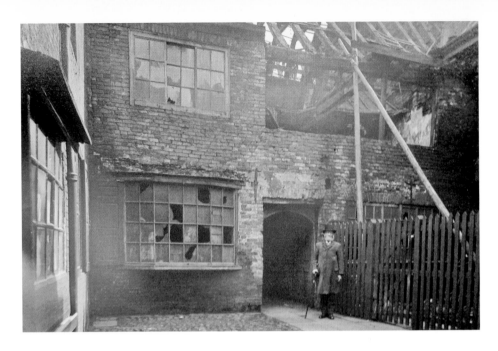

Barley Hall

Parts of Barley Hall go back as far as 1360, when the hall was built as the York townhouse for Nostell Priory, the Augustinian monastery near Wakefield, by Thomas de Dereford, the Prior from 1337 to 1372. The priors of Nostell were prebendary canons of York Minster and attended ceremonies, services and business meetings in the city; a hostel, therefore, made good business sense. However, by the fifteenth century, the priory had fallen on hard times and Barley Hall was leased to private tenants. A new wing was added in about 1430 and in 1460 it was rented out to William Snawsell – goldsmith, Master of the King's Mint in York, Member of Parliament for York, alderman, and Lord Mayor of York in 1468. The older pictures here and on page 15 show the hall before the marvellous reconstruction work.

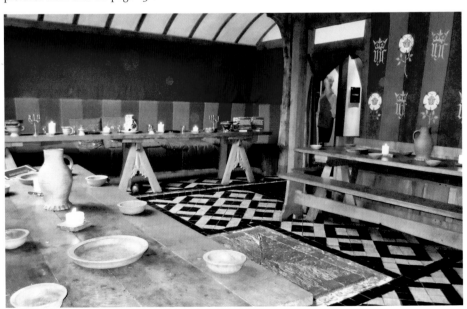

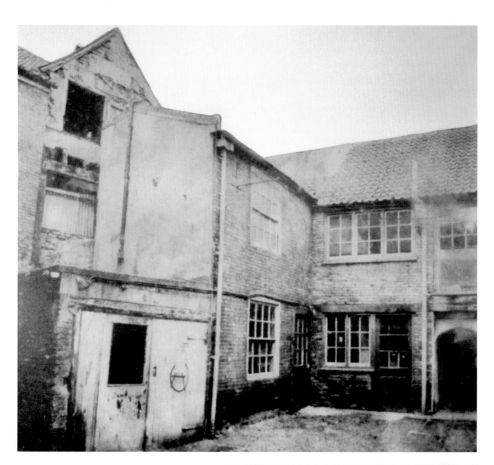

'A Warren of Tradesmen's Workshops'

By the seventeenth century, Barley Hall was subdivided into a number of smaller dwellings with the result that the 'screens passage' – the internal corridor area at the end of the great hall – came to be used as a public short-cut from Stonegate to Swinegate. To this day it remains a public right-of-way, and it is now known as Coffee Yard. By Victorian times, the house was 'a warren of tradesmen's workshops'; its last use before being sold for redevelopment in 1984 was as a plumber's workshop and showroom. The hall was painstakingly restored to its former glory and it reopened to the public in 1993. Barley Hall is named after Professor Maurice Barley, founder president of York Archaeological Trust.

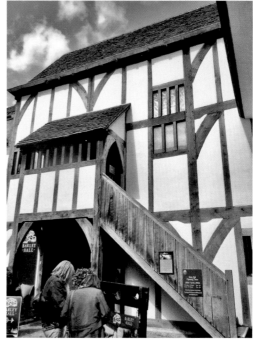

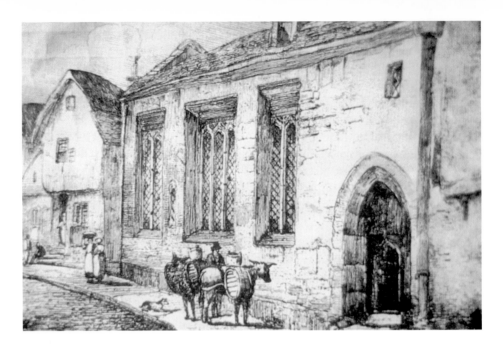

Bedern Chapel

Nearby Bedern Hall was the first home of the thirty-six Vicars Choral of York Minster from 1349. It originally featured a bridge linking it to Minster Close, making it easy for the vicars to get to the Minster without having to interact with the common people (see page 62). The present hall dates from 1370 and was used until 1650. By the nineteenth century it had become divided into slum tenements, largely for Irish navvies – a 'sad spectacle of poverty and wretchedness'. The Guild of Freemen, the Company of Cordwainers and the Guild of Building now occupy the hall.

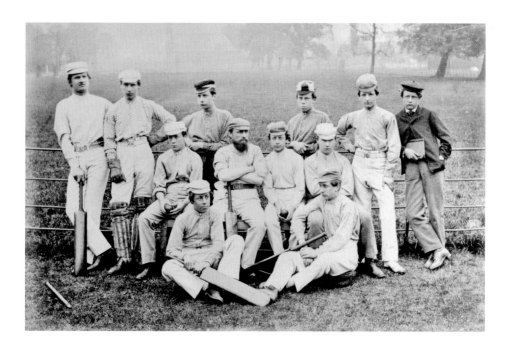

Bootham School

It was William Tuke (1732–1822) who first raised the idea in 1818 of setting up a boys' school in York for the sons of Quakers 'and any children of the opulent who will submit themselves to the general system of diet and discipline'. In 1822, premises on Lawrence Street were leased from the Retreat (the revolutionary psychiatric hospital run by the Quaker Committee in York), and the school opened in early 1823 as the York Friends Boys' School. From 1829 it became known as Yorkshire Quarterly Meeting Boys' School, which remained its official name until 1889, even after it had moved to new premises at 20 (now 51) Bootham in 1846. It was the school's proximity to the River Foss that triggered the move to more salubrious premises; one master carried a pistol to shoot the rats, and cholera was a problem. The photographs show cricket in 1867 and 2010.

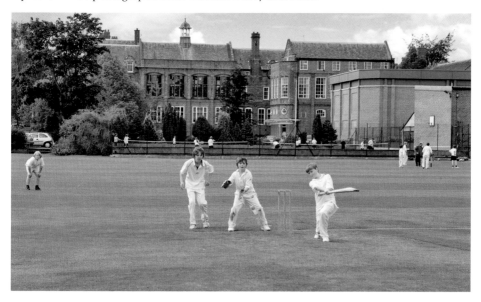

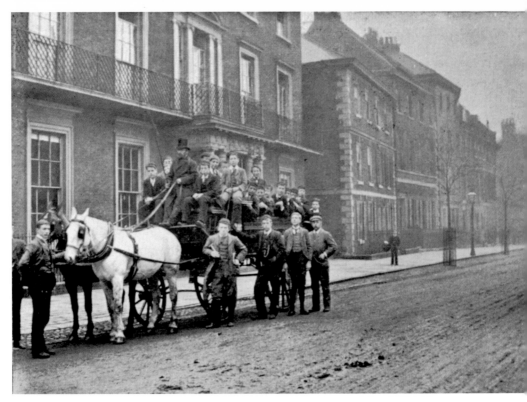

Bootham School and Chocolate Jumbo

In the late nineteenth century, many of the Rowntree family boys were educated at Bootham. One of them, Arthur Rowntree (or Chocolate Jumbo, to give him his nickname), was headmaster (1899–1927). Arthur Rowntree said, 'We are proud to be in the tradition of promoting friendship between all classes.' A number of staff and scholars were influential in the political and social reforms of their times, not least Seebohm Rowntree (Bootham 1882–87), who used pioneering statistical methods to expose the fact that in York almost one-third of the population lived at or below 'sustenance level'. An early 1900s school trip is shown above; the new photograph shows school dinners today – far removed from the lumpy custard and stodge of yesteryear.

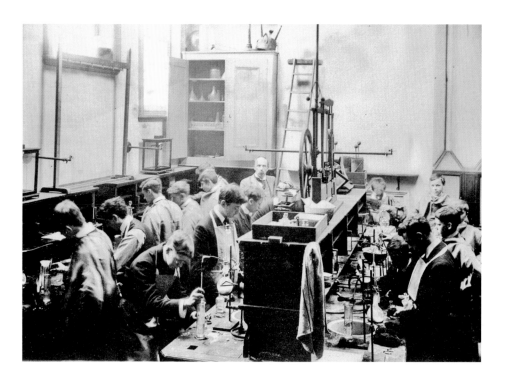

Boiling Snails Can Damage Your Health

In 1899, almost the entirety of Bootham School was destroyed by fire: a keen pupil was boiling snail shells in the natural history room when he was summoned by the bell for reading, and the snails were left boiling all night... On being informed by the fire brigade that his school was a smouldering shell, the headmaster promptly resigned. For a while, the school also owned No. 54 Bootham, the birthplace of W. H. Auden, whose father was a medical officer. The old picture shows an 1899 lower senior chemistry class; the teaching in action in the newer photograph is less formal.

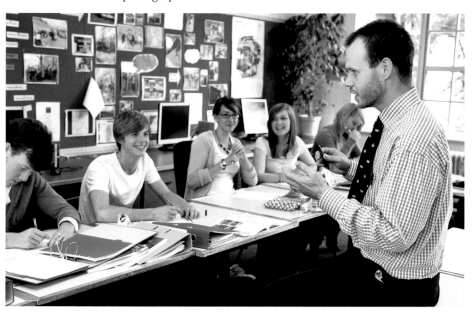

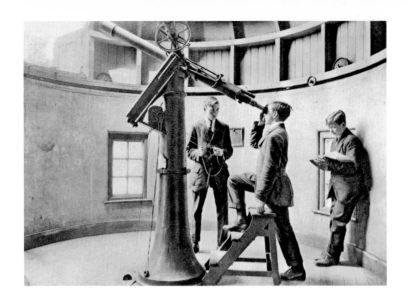

The Wrong Sort of Balls

In 1862, Bootham's headmaster, John Ford, visited Matthew Arnold at Rugby and saw the game of rugby football being played. He brought the game back to Bootham, but had not taken into account the shape of the ball. He therefore introduced rugby with a round rather than an oval ball. Nor did he ever master the rules, and by 1867 the Bootham game was still 'an ill-regulated scramble for the leather by as many as could be got to take part!' Bootham's most famous athlete was Philip Noel Baker, a silver-medallist runner in the 1912 Stockholm Olympic Games who was awarded the Nobel Peace Prize in 1959 for his work on disarmament and international peace. Apart from many boys from the Rowntree family and other Quakers from the Cadbury and Clark families, alumni include A. J. P. Taylor and J. B. Morrell. In 1850, Bootham became one of the first schools to have its own observatory, with the two telescopes made for the school by local firm, Cooke, Troughton & Sims. The one pictured here in 1919 is a 4-inch refracting telescope. The photograph below shows the school today.

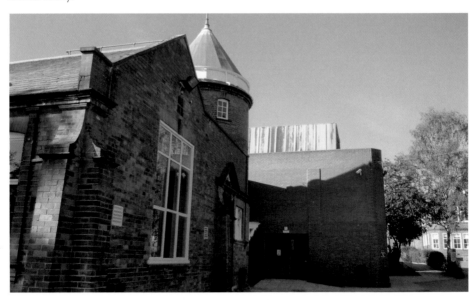

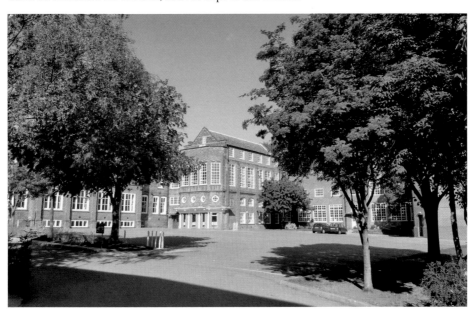

'Friends, Romans, Countrymen'

Bootham School was moved to Roman Catholic Ampleforth during the Second World War; Donald Gray, the head at the time, is reputed to have addressed the combined school as 'Friends, Romans, Countrymen'. Bootham was not the only Quaker School in York: in 1827, the Hope Street British School was established and attended by many children of Friends. It was slightly unusual because, in addition to the usual curriculum, it taught the working of the electric telegraph, with the Electric Telegraph Company supplying the instruments and the school supplying the company with clerks. The old picture shows some 'columns', a basic system of punishment for talking in class or forgetting books that is still in use today. Columns could be redeemed for rewards, such as trips to the cinema.

The Castle Museum

By common consent one of Britain's leading museums of everyday life, York Castle Museum is particularly famous for its Victorian street, named Kirkgate after the museum's founder, Dr John L. Kirk. Kirk was a doctor whose passion was collecting everyday objects; in time he needed somewhere to keep them safe for future generations to enjoy. It is this generous ambition that led to the Castle Museum we know today. The pictures show Kirkgate in the 1950s and as it is today – or should that be as it was in Victorian times?

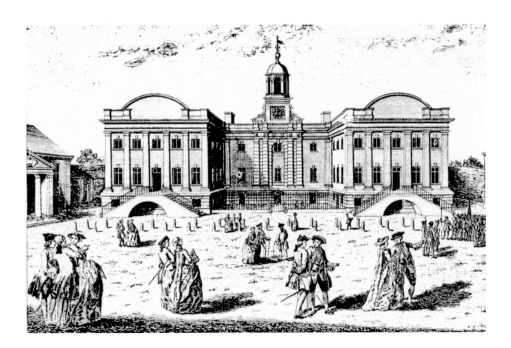

Dick Turpin, Horse Thief and Highwayman

The Castle Museum is housed in two former prison buildings: the Debtors' Prison and the Female Prison – a background vividly explored today when visitors meet former prisoners. The most notorious is highwayman Dick Turpin, who was hanged at the Knavesmire in 1739 for horse stealing: he was incarcerated for six months before his execution in the Debtors' Prison, which was built in 1701–05; the Female Prison was built later, in 1780–83. The museum, which opened in 1938, is named after York Castle, whose bailey originally occupied the site. The 'new' picture is of a typical 1960s sitting room on display there.

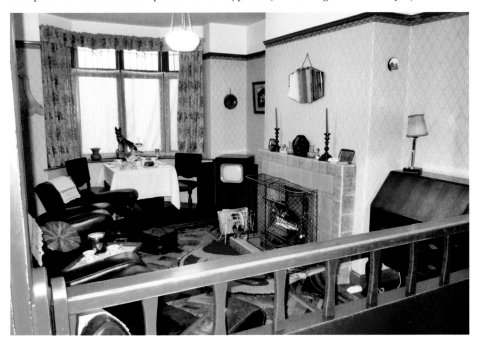

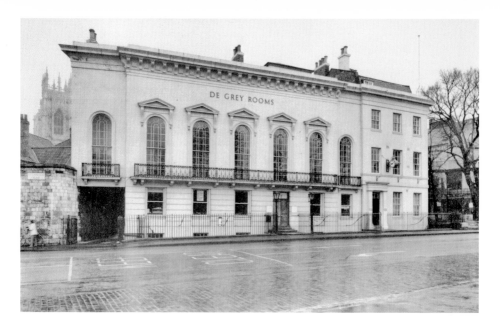

The De Grey Rooms

The fine neo-classical building that houses the De Grey Rooms has long been a place of entertainment, a tradition only recently punctuated when it served as the city's principal tourist information office. The money for it was raised by public subscription in 1841 and it was designed by George Townsend Andrews, who had made a name for himself with his work on York railway station. Originally, the rooms were home to the officers' mess of the Yorkshire Hussars. They later became a popular venue for balls, concerts and parties. The name derives from Thomas Philip de Grey, colonel-commandant of the Yorkshire Hussar Regiment. In 2011, the rooms reverted to their function as a venue for dance and dancing when they were annexed by York Theatre Royal next door to stage dance and theatre productions. Appropriately, the theatre hosted a ten-hour 'Dance-A-Thon' in April 2011 to help raise the £50,000 needed for refurbishment.

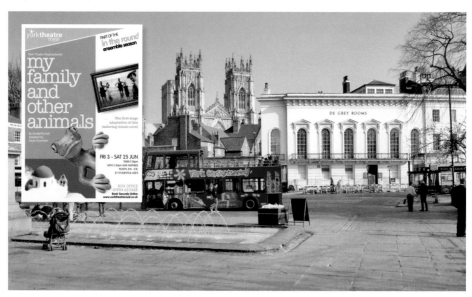

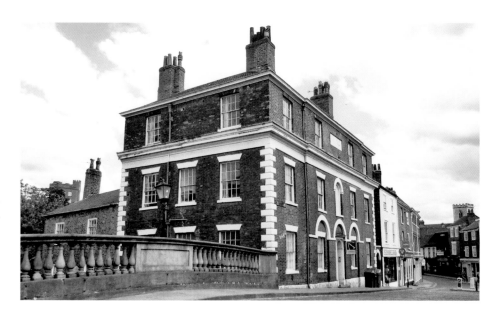

Dorothy Wilson's School

Dorothy Wilson was a local benefactor whose legacy includes schools at nearby Skipwith (founded 1710, now the church hall) and Nun Monkton (1717). Her 1719 York almshouse-cum-schoolroom is by Foss Bridge. Although converted into apartments, it is still an imposing and elegant building. Baines' *Directory* of 1823 describes the almshouse as 'a neat brick-building of modern appearance, very convenient to the inmates, and rather ornamental than otherwise, to the part of the town in which it stands'. You can still see the inscription on the façade that commemorates Dorothy Wilson's charity for the 'Maintenance of ten poor Women as also for the instruction in English, Reading, Writing and Clothing of twenty poor Boys for ever'. There is also a memorial tablet to Dorothy Wilson on the wall in St Denys' church nearby (pictured below).

Fairfax House

One of the finest Georgian townhouses in England, Fairfax House was originally the winter home of Viscount Fairfax, having been purchased in 1760 as a dowry for Anne Fairfax. Its richly decorated interior was redesigned in the classical style by York architect John Carr, with a magnificent staircase and ceilings, a Venetian window and iron balusters. Adapted in the last century for use as a cinema and dance hall, Fairfax House was restored to its former glory by York Civic Trust in 1982–84. Sir Simon Jenkins said of it in 2003, 'It is the most perfect eighteenth century townhouse I have come across anywhere in England.' The Noel Terry collection of furniture, clocks, paintings and decorative arts, described by Christie's as one of the finest private collections of the twentieth century, furnish the house. One example of the marvellous reconstruction is given in these photographs.

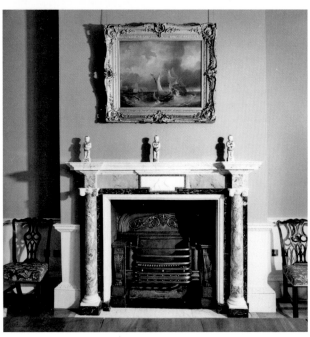

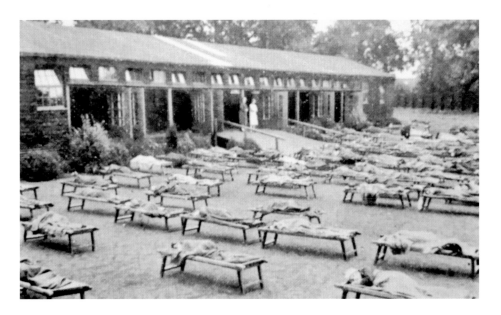

Fulford Open Air School

Originally opened at 11 Castlegate in 1913 in the same building as the Tuberculosis Dispensary, Fulford Open Air School moved to a converted army hut in the grounds of Fulford House in 1914 and became known as Fulford Road School for Delicate and Partially Sighted Children. The open air school movement was set up in 1904 in Berlin to curb the development of tuberculosis in children and, as such, required the establishment of schools that combined medical care with teaching adapted to pupils with pre-tuberculosis. Cured pupils were moved on to other schools. Fulford closed in 1960 and was demolished in 1964. The Holgate Bridge School for Mentally Defective Boys was opened in 1911 and moved to Fulford House. In 1923, it became known as the Fulford Road School for Educationally Sub-Normal Children. Pupils at the school are pictured in the old photograph; the new picture is of the Sir John J. Hunt almshouses, which were built nearby in the 1950s for local brewery workers.

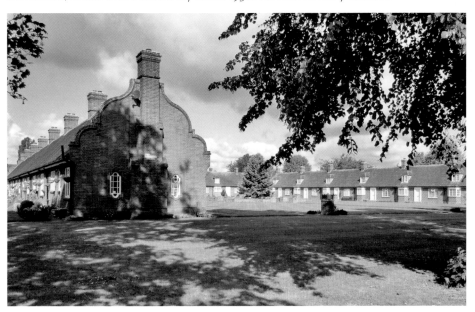

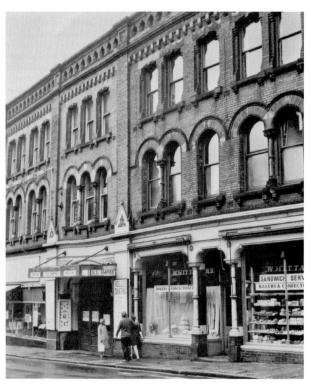

Grand Opera House

The opera house became a theatre almost by accident; the buildings in which it exists today were originally constructed as the city's Corn Exchange in 1868, the intention being to use it as a concert hall on an ad hoc basis. The auditorium was a warehouse opening on King Street. William Peacock converted the Corn Exchange into the Grand Opera House and opened on 20 January 1902 with *Little Red Riding Hood*, starring Florrie Ford. In 1903 it had a subtle but important change of name to 'the Grand Opera House and Empire' so that regulations banning smoking in theatres could be circumvented –the then fashionable habit of smoking was permitted in music halls. The older photograph shows the Grand Opera House in its roller-skating days.

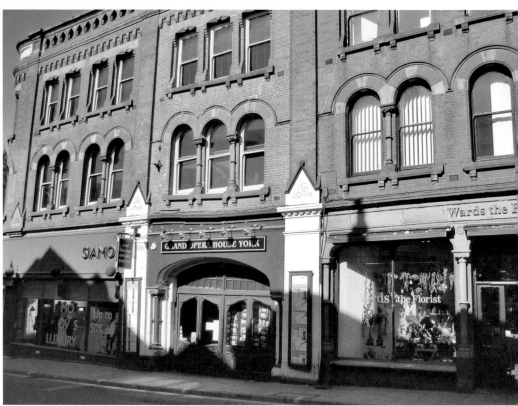

Laurel and Hardy and Morecambe and Wise

The Grand Opera House stayed with William Peacock's family until 1945, providing a varied programme that included pantomime, music hall, variety, serious theatre, amateur opera, plays, revues, and silent films. Performers included Charlie and Sydney Chaplin, Gracie Fields, Lillie Langtry, George Robey, Cecily Courtneidge and Jimmy Jewel. In 1945–56, F. J. Butterworth owned the theatre and stars such as Vera Lynn, Laurel and Hardy and Morecambe and Wise appeared. The old image is of a 1960s Grand Opera House production; the new one shows the Friargate Theatre, home of the independent Riding Lights Theatre Company since 1999, when it opened with Ben Jonson's *The Alchemist*. June 2011 saw the opening of York's newest theatre, the Scenic Stage Theatre at the University of York, with a production of Thomas Middleton's *A Mad World, My Masters*. A good year for theatre in York – it also saw the reopening of the refurbished Barbican Theatre.

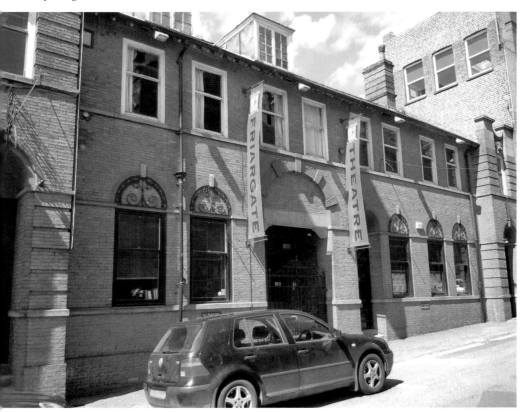

Ellen Kent presents the
Chisinau National Opera

BIZET

SOUVENIR BROCHURE
Autumn 2005

CARMEN

Wrestling

In 1958, Shepherd of the Shambles bought the Grand Opera House, and it became the S. S. Empire. The stage, lower boxes and raked stall floor were removed and replaced by a large, flat floor suitable for roller-skating, dancing, bingo and wrestling. In 1987, new owners the India Pru Co. spent £4 million restoring it to its former glory. The decor is very similar to how it was originally; the carpet is a rewoven copy of the original – with the Grand Opera House logo incorporated into it – and the light fittings are in the period style. The pictures demonstrate the diversity of productions offered; one from 2005 and the other 2011.

PHIL MCINTYRE ENTERTAINMENTS

THE CAT

JOHN CLEESE

The Alimony Tour 2011

Grays Court and the Blue Stockings

This is probably the oldest continuously occupied house in the country; parts of it date back to 1080, when it was commissioned by the first Norman Archbishop of York, Thomas de Bayeux, as the official residence for the Treasurer of York Minster. It exudes history: James I dined here with Edmund, Lord Sheffield, the Lord President of the North, knighting eight noblemen in the Long Gallery in one evening. Sir Thomas Fairfax owned Grays Court between 1649 and 1663, during which time he laid siege to the city. James, Duke of York, and Maria Beatrix of Modena, his wife (later King and Queen of England, Ireland and Scotland), stayed in Grays Court in 1679. Elizabeth Robinson was born here in 1718: she founded the Blue-Stocking Club, 'where literary topics were to be discussed, but politics, gossip and card-playing were barred'.

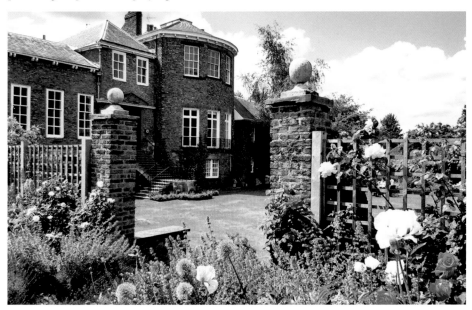

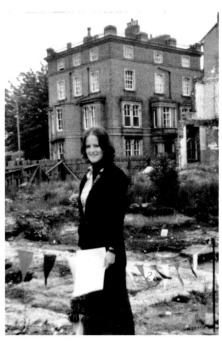

Jorvik Viking Centre

The only significant Viking archaeological finds in York before the 1970s were dug up by chance. But this all changed when an area below Lloyds Bank in Pavement was excavated by York Archaeological Trust before the redevelopment of Coppergate in 1976. Within days, rare traces of Viking Age timber buildings were revealed. The dig covered 1,000 square metres and between 1976 and 1981 archaeologists were able to excavate 2,000 years of York's history. In that time, York Archaeological Trust identified and recorded around 40,000 items. The site revealed five tons of animal bones (mostly food leftovers); vast quantities of oyster shells (a cheap and popular food over the years); thousands of Roman and medieval roof tiles; building materials including wattle, timber and metal slag; 250,000 pieces of pottery; and 20,000 other individually interesting objects. The old picture shows the archaeological site, the new picture a scene from the Jorvik Viking Centre, which was built on the site.

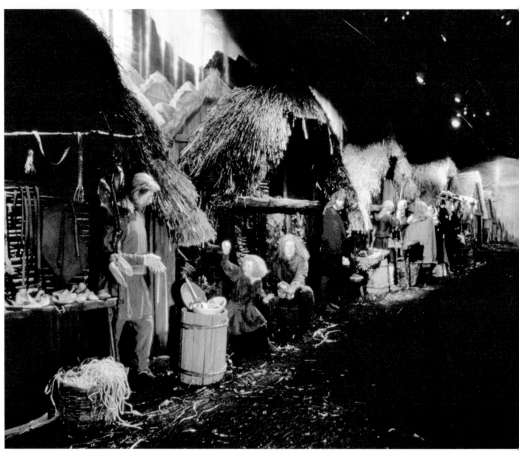

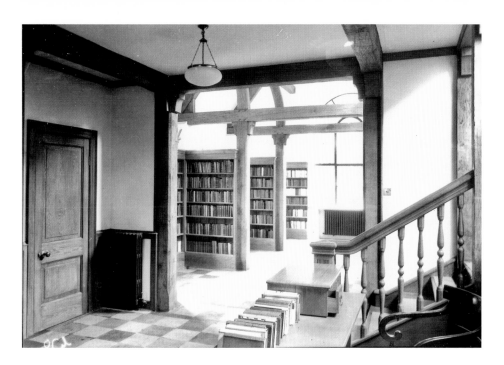

Joseph Rowntree Memorial Library

Joseph Rowntree's many legacies reveal his enlightened attitude to industrial relations. In 1885, he stocked and opened a library for his workers putting in £10 and this was matched by a grant from the Pure Literature Society. There were originally three libraries. The Staff Library held 10,000 books, half of which were fiction, 4,000 non-fiction and 1,000 juvenile. The Lads' Library had 250 books for the Boys' Club. The Technical Library kept 7,000 books and 8,000 pamphlets, as well as 300 subscriptions to magazines and journals. The Joseph Rowntree Memorial Library was erected in 1927 in Haxby Road in gratitude for a life of devoted service. Another example of his cultural philanthropy is the famous Joseph Rowntree Theatre, also on Haxby Road.

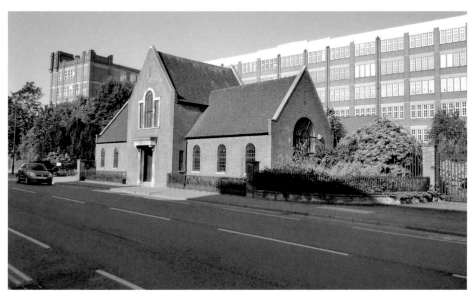

ROOMS

Attached to the room is a modern flat in which the Domestic Subjects Mistress and the Headmaster's Secretary reside. The girls work in this flat in pairs for a fortnight at a time and are allowed to invite visitors to morning coffee and to lunch ; parents are welcomed. Following upon this period in the flat, the girls undertake a week's work at the Nursery School in the village.

A special room for the teaching of needlework has been provided at the east end of the front block. It is larger than an ordinary form room, light and airy, and is well equipped with all the necessary apparatus. The room is furnished with polished light oak tables and chairs.

In addition to their normal work, the girls are encouraged to maintain contact with the gardening and artcraft classes. They assist with the feeding of livestock and keep the building bright with twigs and flowers throughout the year.

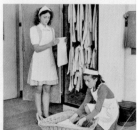

Joseph Rowntree School

The old pictures on pages 34–6 are taken from the 1946 school prospectus. The new school is a fitting twenty-first-century testament to Joseph Rowntree's turn of the twentieth-century vision. It cost £29 million and opened in February 2010. Domestic science in the 1940s and '50s included cooking by electricity, gas or coal, working in the domestic flat adjacent to the department (which was used by the Domestic Subjects Mistress), assisting in the village nursery school, and feeding the animals. The gym (see page 36) could accommodate a full-size boxing ring when required and had a radiogram and piano for use during folk dancing. The sports hall in the new school has a 595-square-metre wooden sprung floor and can be set up for a wide range of sports, including volleyball and tennis. There is also a 57-square-metre multi-gym with cardiovascular machines and weights. These are complemented by six outdoor tennis or netball courts.

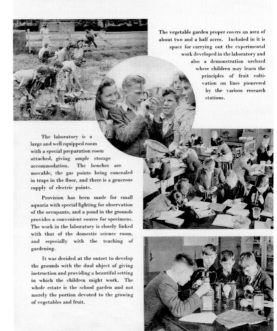

THE LABORATORY,

The vegetable garden proper covers an area of about two and a half acres. Included in it is space for carrying out the experimental work developed in the laboratory and also a demonstration orchard where children may learn the principles of fruit cultivation on lines pioneered by the various research stations.

The laboratory is a large and well equipped room with a special preparation room attached, giving ample storage accommodation. The benches are movable, the gas points being concealed in traps in the floor, and there is a generous supply of electric points.

Provision has been made for small aquaria with special lighting for observation of the occupants, and a pond in the grounds provides a convenient source for specimens. The work in the laboratory is closely linked with that of the domestic science room, and especially with the teaching of gardening.

It was decided at the outset to develop the grounds with the dual object of giving instruction and providing a beautiful setting in which the children might work. The whole estate is the school garden and not merely the portion devoted to the growing of vegetables and fruit.

Keep the Noise (of Your Skin) Down!
The original Joseph Rowntree School was designed as an open-air building. Innovations included: large, south-facing windows 'capable of any required degree of opening' depending on the weather or time of year and low enough for pupils to see through when at their desks; ceiling heating panels; and 'the long principal corridor ... slightly curved so as to minimise noise transmission by means of skin friction'. The garden comprised 2½ acres and included a demonstration orchard to teach the principles of fruit cultivation; there were two further acres for raising livestock, and an apiary.

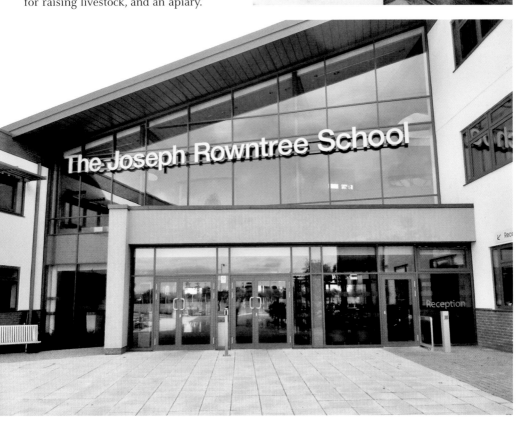

PHYSICAL EDUCATION

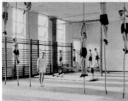

The gymnasium is unusually large, being 70 feet by 40 feet by 16 feet. The lights are sunk into the ceiling. At each end of the gymnasium the following are provided : changing room, shower, drying space, lavatories, and heated stores for kit. The instructors have their own rooms, each with its own shower. There is a piano, and a power point for a radiogram when required for folk-dancing. The gymnasium has a door at either end opening on to an asphalted area behind the school. The playing fields proper, as distinct from the ornamental grounds, cover about ten acres and, throughout the whole of the period the school has been open, have been used for the production of foodstuffs. Alternative accommodation is available in the park on a site of some sixteen acres, which, it is hoped, may eventually become part of the school estate. In both the assembly hall and the gymnasium, provision has been made for the erection, when required, of a full sized boxing ring, this facility being greatly appreciated by members of the Youth Club and Evening Institute.

'Forgot My Towel, Sir!'
The Joseph Rowntree School was opened on 12 January 1942 by Rab Butler to cater for 480 children from the village and surrounding area. As with the earlier primary school, it was nothing if not innovative, taking advice, for example, from the National Institute of Industrial Psychology on ergonomic matters such as ventilation, heating and lighting. From the very start, practical skills were valued and taught just as much as academic subjects, as the older photographs here demonstrate. The new picture is of the Hub in the new school.

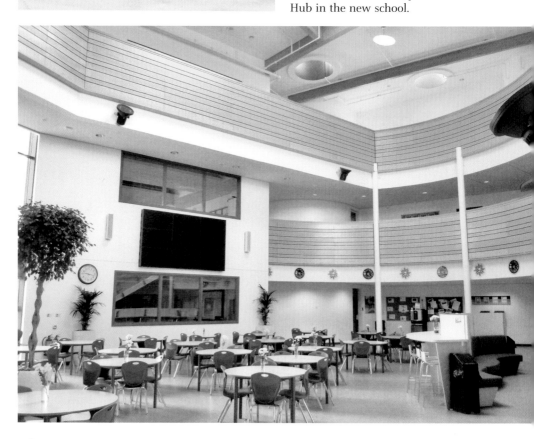

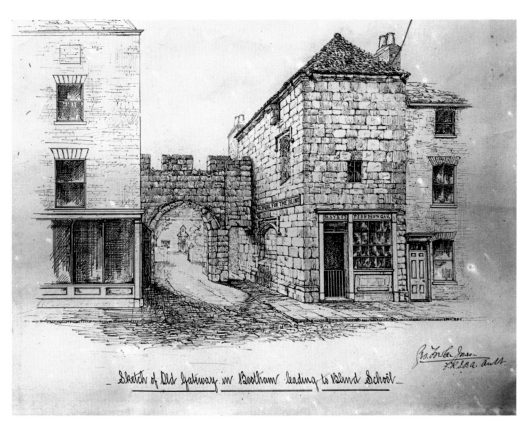

Sketch of Old Gateway in Bootham leading to Blind School

The King's Manor and the Yorkshire School for the Blind

The Wilberforce Memorial was the charity behind the Yorkshire School for the Blind; it was established in response to the death of William Wilberforce in 1833 out of a desire to honour his memory and good works in as fitting a manner as possible. Wilberforce had represented Yorkshire as an MP for twenty-eight years and was an influential voice for the movement to abolish the slave trade and for the education and training of the blind. The school's mission was: 'To provide sound education together with instruction in manual training and technical work, for blind pupils, between the ages of five and twenty; to provide employment in suitable workshops or homes for a limited number of blind men and women who've lost their sight after the age of sixteen, in some occupation carried on at the school; and to promote such other agencies for the benefit of the blind as may enable them to gain their livelihood, or spend a happy old age.'

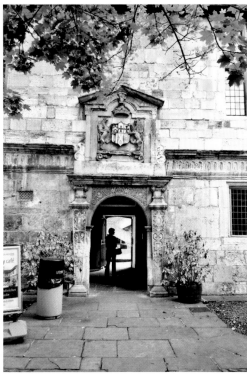

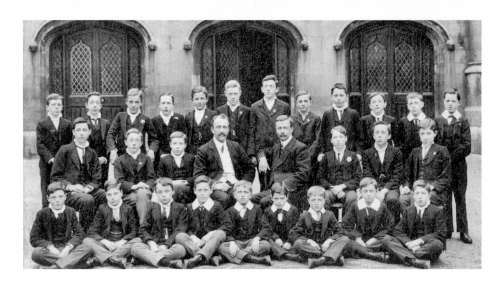

The Minster School

Formerly known as the Minster Song School, it focuses on music and singing: of the 180 or so pupils, forty are choristers at York Minster. Historically, the choristers had to read lessons, carry the cross and candles in procession, swing censers, see to the numerous changes of cope for the celebrant during the mass and hold the book for the gospeller. There were three rows of seats, or 'forms' – giving us the derivation of 'forms' in the sense of a desk. In 1903, Dean Purey-Cust made arrangements for a vacant building in Minster Yard to be used as the new song school. Before Deangate was closed to traffic in 1989, pupils were obliged to doff their caps at motorists, who allowed them to cross the road en route to the Minster. With the help of William Etty, a school of art was opened here in 1842 as a branch of the Normal School of Design in London.

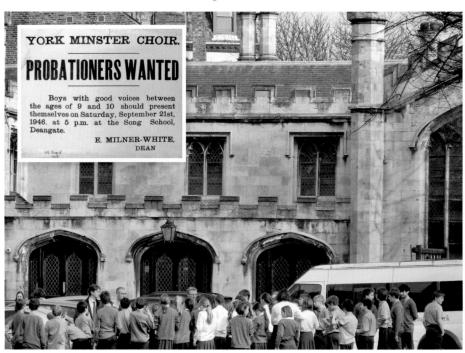

YORK MINSTER CHOIR.

PROBATIONERS WANTED

Boys with good voices between the ages of 9 and 10 should present themselves on Saturday, September 21st, 1946, at 5 p.m. at the Song School, Deangate.

E. MILNER-WHITE, DEAN

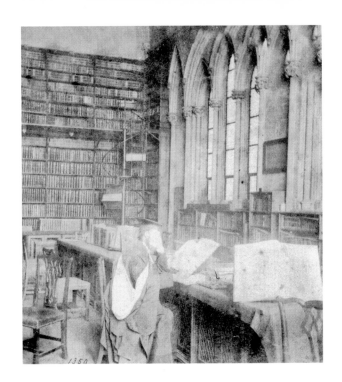

The Minster Library

The Old Palace not only houses York Minster's library and archives but also the collections department and the conservation studio. It is known as the Old Palace because part of the building used to be the chapel of the thirteenth-century archbishop's palace. In 1810 it was refurbished and, shortly after that, the Minster's collection was installed. The original library was the dream and ambition of King Egbert, a disciple of the Venerable Bede: he opened a school of international repute and started a collection of books. The librarianship then passed in the 770s to Flaccus Albinus Alcuinus, better known as Alcuin. He presided over York Minster Library from c. AD 778 to 781 and later became one of the architects of the Carolingian Renaissance. Alcuin's catalogue featured works by many of the Church Fathers and classical authors such as Pliny, Aristotle, Cicero and Virgil – but all was lost when the Minster and library were sacked by the Vikings. The old photograph is of a scholar at work in the library.

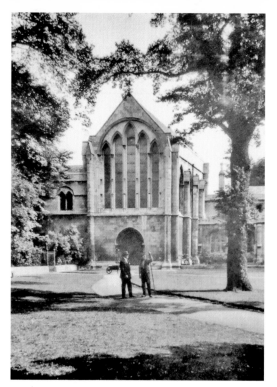

The Finest Cathedral Library in Britain

It was not until the eighteenth century that the Minster Library's collection started to grow significantly: from 1716 to 1820, there were more than 1,200 loans by 179 different borrowers. Laurence Sterne, author of *The Life and Opinions of Tristram Shandy*, was a regular user. By 1810, there were nearly 8,000 volumes and the library moved to its present home in Dean's Park; in 1890, Edward Hailstone bequeathed 10,000 volumes. Sadly, many books were sold to raise money for the planned repairs, including a 1519 Erasmus New Testament for £20,000. The proceeds of the sales went to a new library fund, started in 1945. Today, the Minster Library is unquestionably the finest cathedral library in Britain.

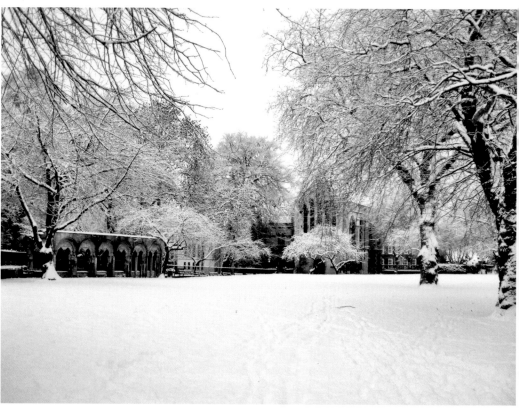

Golden Wedding
BRYCE
Charles & Rose
(née Harrex)

Married 29 June 1968

Celebrating 50 wonderful

years together

You tucked us in at night,
You taught us to play dominoes and cards
and how to cheat,
You taught us that to give is better
than to receive,
You gave us hugs when we most needed,
You made us feel loved and so warm.
Without you in our lives we would have
been just ordinary grandchildren,
With you in our lives we were the luckiest
people in the world,
Rest with Grandma now Grandad,
your work is done,
You shall never be forgotten
nor out of our hearts,
'Grandad Joe' shall be talked about for
the rest of our lives.
Love you to the moon and back.
**Nichola, Paul, Gracie,
Maximus & Tobias**

ELLIS Joe

Dad, grandad and great grandad
12.04.1920 - 23.06.2018.
On Saturday 23 June 2018,
Passed away at Beechtree Care Home

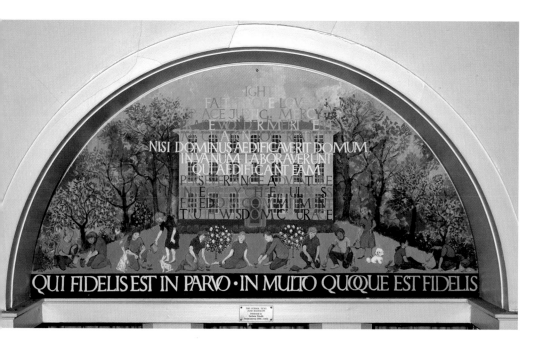

The Mount School

The story of the Mount School begins with Esther Tuke, second wife of William Tuke, who in 1785 opened the boarding school in Trinity Lane, off Micklegate and known then as the Friends' Girl School. The aims of the York school were heavily influenced by the famous Quaker school at Ackworth near Pontefract, which was founded in 1779 by John Fothergill and which, in turn, was previously a (particularly insalubrious) branch of the London Foundling Hospital in Bloomsbury. Fothergill, a Quaker physician, teamed up with William Tuke and David Barclay (of banking fame) to open the school for Quaker children 'not of affluence'. Despite their best intentions, it had a reputation for being 'harsh, if not barbarous'. The 'old' picture is a 2000 mosaic showing the school. The new photograph shows Boxo the clown at Tregelles.

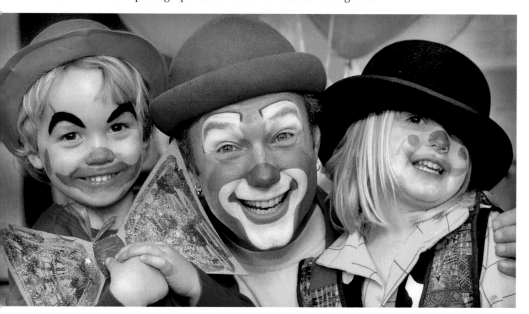

MOUNT MAGAZINE.

CHARMING.

The photographs on pages
41–8 were originally published in
Sarah Sheils' *Among Friends: The
Story of the Mount School* (2007)
and appear here with permission.
Trinity Lane pupils include the
daughters of Abraham Darby III
of Coalbrookdale, the famous
ironmaker. By 1796, Trinity Lane
could not accommodate the
thirty or so girls and so purpose-
built premises were bought for
£450 in Tower Street near to
York Castle and the Friends'
Meeting House. William Tuke
eventually retired in 1804, but
the school was in financial
difficulties and closed in 1812. In
1829, Samuel Tuke established
the York Friends' Boys' School
(later Bootham School) and
then turned his attentions to
establishing a girls' equivalent
along the same lines. The old
image is the Jack and Jill cover
of the 1892/93 *Mount Magazine*.
The new picture shows a
dramatic chemistry lesson.

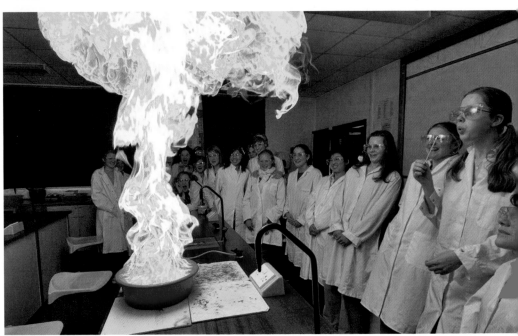

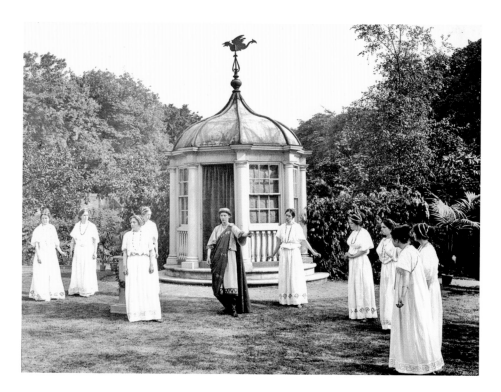

The Castlegate Years

The York Quarterly Meeting Girls School materialised in Castlegate House in 1831, the 1763 mansion of the Recorder of York. The day was long at Castlegate, with lessons from 7 a.m. to 5 p.m. followed by private study for an hour at 7 p.m. and scripture readings from 8 p.m. Lessons included Latin, Greek, arithmetic, mathematics, art, grammar, French and posture. Posture was not popular, involving as it did instruction on how to bow, shake hands and stand with pointed toes. The older photograph shows Mount girls in the garden. The new photograph shows a hair-raising physics lesson.

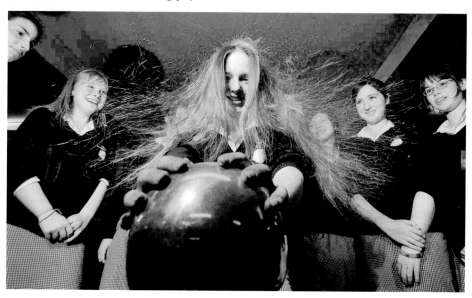

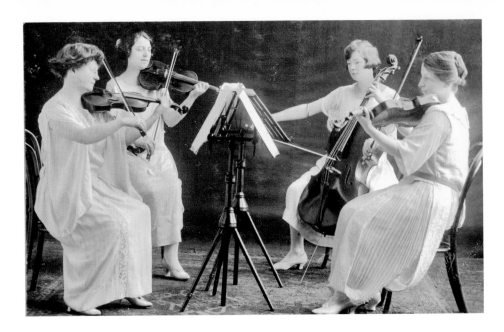

The Mount and Rachel Tregelles

Girls from the Mount attended lectures given by the Yorkshire Philosophical Society, adding to and annotating their own collections of shells, minerals and pressed plants. In 1855, the lease on Castlegate expired, thus triggering the move to the purpose-built buildings at the Mount: 353 girls had been educated and fifty-four had completed teacher training at Castlegate. The Mount School opened its doors in 1857 under the supervision of Rachel Tregelles. The girls lived four or five to a bedroom rather than in dormitories and enjoyed the luxury of internal flushing toilets and hot water on tap. Fees were £47 11s 2d per year. The old picture is of a Mount string quartet performing during the First World War; the new picture shows Tregelles transformed into a wizard school.

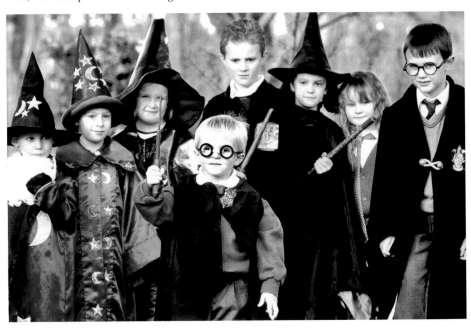

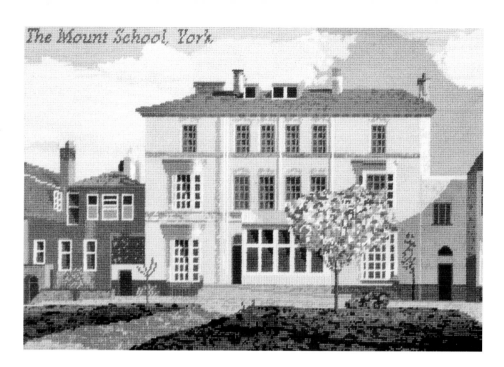

'Girls... Are Incapable of Taking a Degree Course'

Lydia Rous took over as superintendent of the Mount School in 1866 and it was she who ensured that Mount girls entered the new public examinations. The University of London was not interested; their view was that 'girls were poorly educated and therefore incapable of taking a degree course', but the University of Cambridge, which established Emily Davies' Girton College for women in 1873, took them on board. In 1901, under the aegis of Winifred Sturge, a graduate of London University's Westfield College, the Mount Junior School opened across the road, founded on Montessori principles. It includes among its former pupils the Marxist historian Christopher Hill, six of the children of Arnold and Mary Rowntree, William Sessions, the York printer and publisher, and his sister.

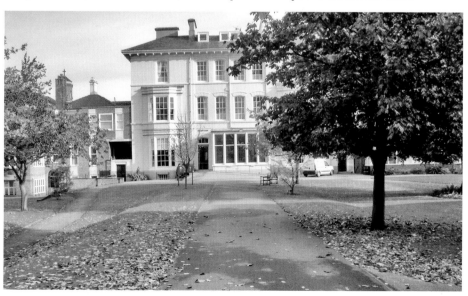

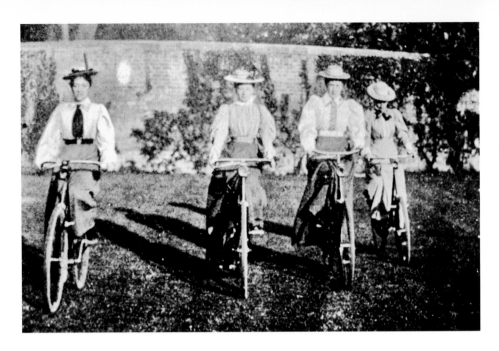

The Effect of Poverty

From about 1912, a shift in admissions policy took place allowing more and more non-Quaker children into the Mount School, which hitherto had been almost exclusively Quaker. By the 1930s, half of the 130 pupils were from outside the Society of Friends. Seebohm Rowntree's landmark *Poverty, A Study of Town Life* (1901) greatly influenced Winifred Sturge: she actively encouraged Mount Girls to go out into the wider community to teach in schools, particularly at Bedern Girls' Club – one of the city's poorest areas. This charitable work continues at the Mount to this day. The old photograph shows Mount teachers cycling in the 1890s. In the new one: 'Hands up who likes yoga!'

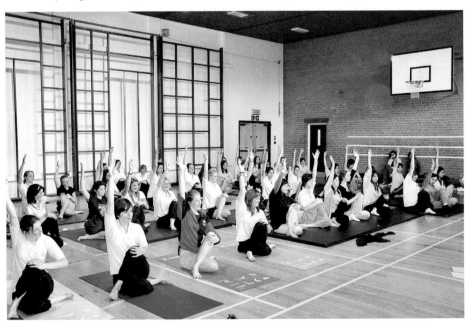

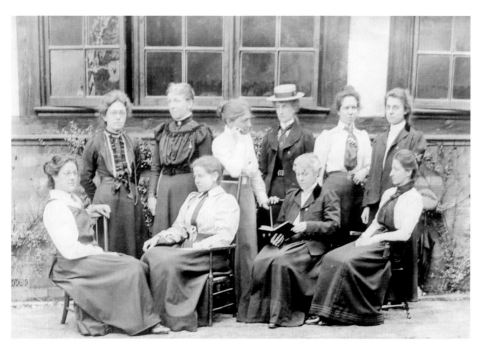

Wire Beds and Benches

The Mount School's new hall and theatre opened in 1931 and staff were given keys for the first time, to allow them to go out in the evenings. During the First World War, the school had been briefly requisitioned as a military hospital, but this turned out to be something of a false alarm as the hospital very soon decamped to the Friends' Meeting House. During the Second World War the school was evacuated to Cober Hill, in Claughton near Scarborough, but this too was temporary: the return to York took place at Easter 1940, but not before £2,000 had been spent on air-raid precautions, including trenches furnished with wire beds and benches. The old picture shows the Mount staff in 1897. Headmistress Lucy Harrison, seated second from right, looks somewhat disinterested.

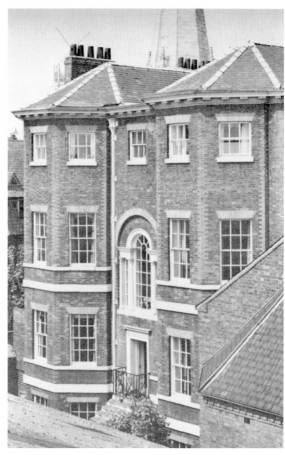

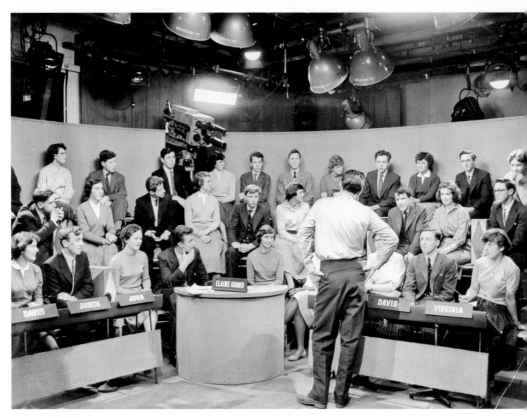

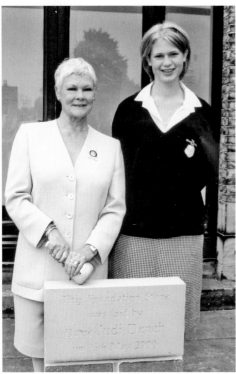

Mary Ure, Judi Dench and the Drabble Sisters

Mount School girls joined the Land Girls and became nurses. The school took in three refugees saved by the Kindertransport movement. Alumni of the main school include actors Mary Ure and Dame Judi Dench, the three Drabble sisters (A. S. Byatt, Margaret Drabble and Helen Langdon), astronomer Jocelyn Bell Burnell and TV correspondent Kathy Killick. The old picture shows the Mount competing in *Top of the Form*; the newer one shows Dame Judi Dench laying the foundation of the new sports hall.

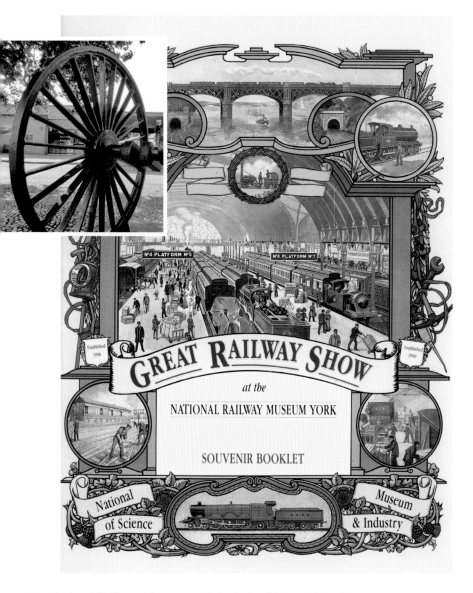

The National Railway Museum and the Bristol Exeter Wheels

It was the Science Museum in London – known then as the Patent Office Museum – that started the country's collection of railway artefacts by buying the *Rocket* in 1866. The North Eastern Railway then opened a public railway museum in Queen's Street, York, in 1927. By the 1930s, all the other railway companies had railway-related collections and these were all combined in 1948 after nationalisation. Under the terms of the 1968 Transport Act, a National Railway Museum was established to house the expanding collection, which was then housed in the British Transport Museum, Clapham, and in the existing York Railway Museum at Queens Street. In 1975, the National Railway Museum opened at Leeman Road. The *Great Railway Show* booklet was published in 1990. The 8 foot 10 inch diameter railway wheels are probably the largest locomotive wheels in existence; they were cast at Bristol in 1873 to drive 4-2-4 Tender Loco No. 40, an express passenger train of the Bristol & Exeter Railway. The wheels have been part of the National Railway Collection since 1964, and have been in their present location since 1975.

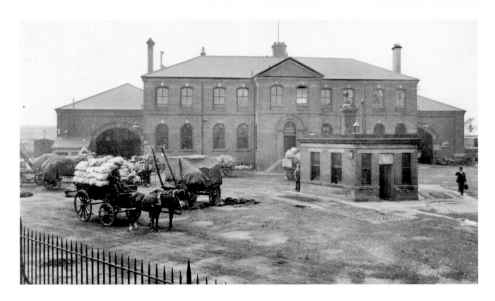

The Institute of Railway Studies, Yorkshire Rail Academy and Search Engine

In 1994, the Institute of Railway Studies was launched as a joint venture between the National Railway Museum and the University of York. In 1999, The Works was opened, effectively expanding the museum to three times its original size. The museum won the European Museum of the Year award in 2001. In 2004, the Yorkshire Rail Academy, a purpose-built rail training centre and the base for the museum's education team, was opened. It was a joint development between York College and the museum. The latest development is Search Engine, the £4 million archive and research centre that gives public access to previously unseen artwork, papers, reports, photographs and artefacts. Search Engine is one of the largest and richest collections of railway-related material in the world. The old picture shows the North Eastern Railway Goods Depot in 1907; the new picture shows how little it has changed in the past century.

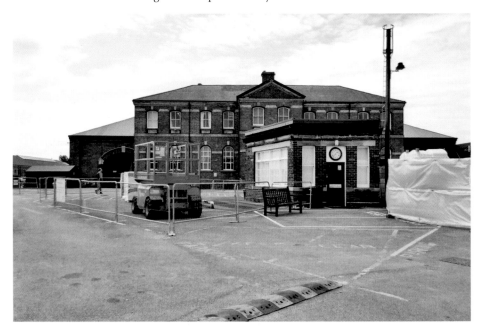

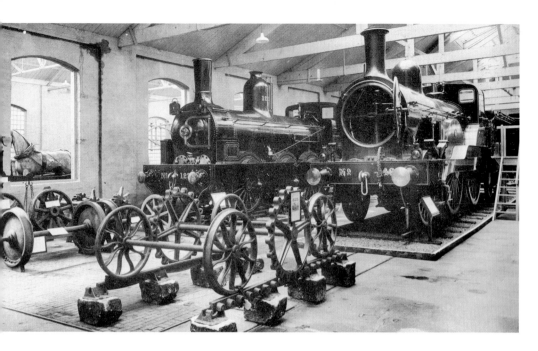

The Queen Street Museum

The old photograph here shows exhibits from the old Queen Street Museum. The modern picture shows the National Railway Museum's miniature train making its way over Lendal Bridge from the Minster on its way back to the museum.

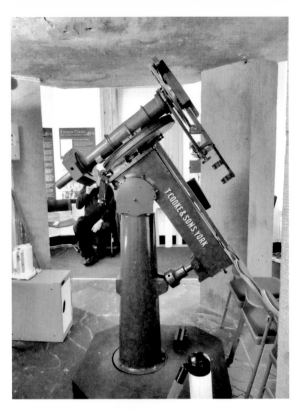

The Observatory

York's observatory was completed in 1833 and its 40-inch refractor telescope was built by Thomas Cooke in 1850 before he went on to make what was then the largest telescope in the world. York played a crucial role in the development of astronomy in the 1780s, when two prominent astronomers – the deaf and dumb John Goodricke (1764–86) and Edward Pigott (1753–1825) – laid the foundations of variable star astronomy, the study of stars of varying brightness. The Observatory also has an 1811 clock, which tells the time based on the positions of stars. At one time it was the clock by which all others in York were set; it is still always four minutes and twenty seconds behind Greenwich Meantime. In the mid-nineteenth century, you had to be either a member of the Yorkshire Philosophical Society or willing to part with sixpence to check a timepiece against the Observatory clock.

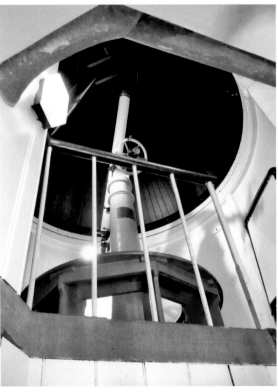

The Observatory and the British Association for the Advancement of Science

The York Observatory originated from a promise made at the very first meeting of the British Association for the Advancement of Science, which took place under the auspices of the Yorkshire Philosophical Society at the Yorkshire Museum in 1831. The Vice-President of the Royal Astronomical Society, Dr Pearson, promised that if an observatory was built in York he would personally supply two of his best instruments. He duly obliged, also providing other scientific instruments – including the aforementioned clock. The conical roof was designed by John Smeaton, designer of the Eddystone Lighthouse. Today the observatory houses a telescope made by Thomas Cooke in 1850, with which you can see the stars and planets at night and safely observe the Sun during the day. The new photograph, taken by Martin Dawson, shows the Moon.

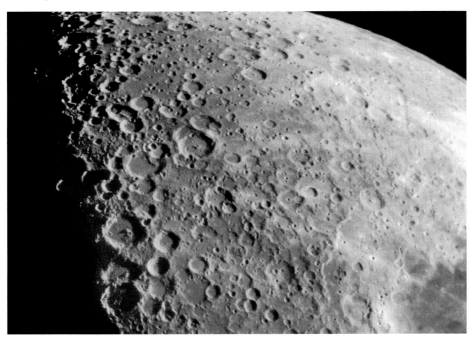

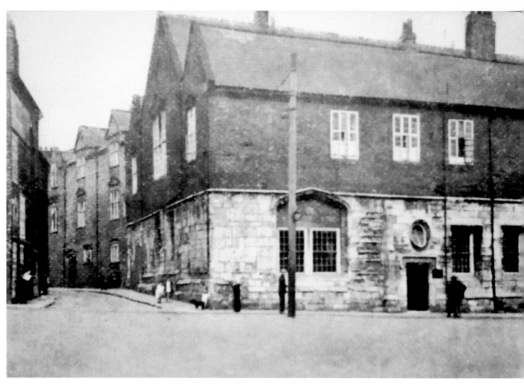

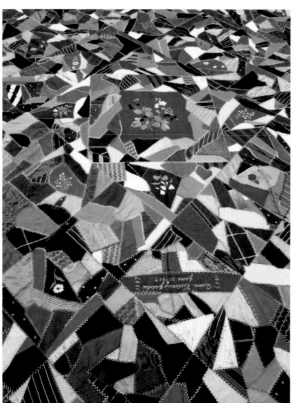

The Quilt Museum and Gallery
Opened in St Anthony's Hall in 2008, this museum holds a unique collection of quilts and related artifacts from around the British Isles, effectively charting the history of this craft. The earliest piece in the collection is the 1718 silk patchwork coverlet. As well as full-size quilts and coverlets, the collection includes among its 700 items miniature pieces, quilted clothing, small domestic items, templates, tools and quilting equipment. The new picture shows one of the exhibits (for more, see page 65).

The Richard III Museum

This museum opened in 1992 and is housed
on three floors inside Monk Bar – one of
York's gatehouses, which were originally built
in the fourteenth century. Monk Bar has been
used over the years as a guard house, prison,
police house and residence. The portcullis
is still operable and was last lowered in
1953. Richard III built the top storey, and he
remains a popular king in York, despite the
very bad press he has received over the years,
particularly from Shakespeare. Apart from
the many intriguing artefacts on display, the
museum offers visitors the chance to attend
the King's trial and offer their verdict as to
whether Richard was guilty of murdering the
young princes. The older photograph depicts
the bar complete with portcullis in 1914.

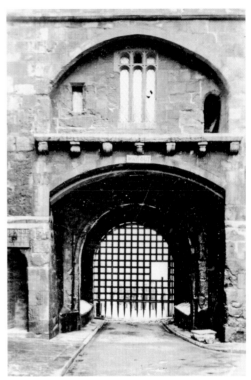

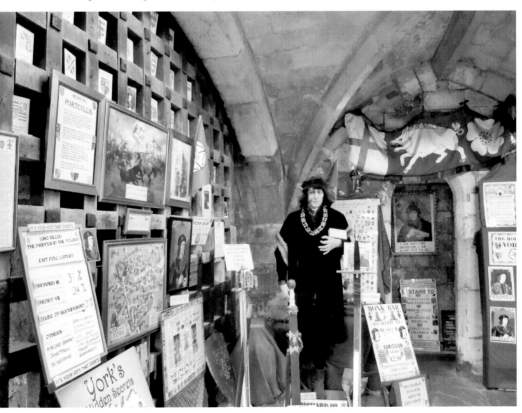

YORK is famed for its SCHOOLS,
among them being

St. Peter's School

the oldest School in the British Isles, possessing documentary evidence of its foundation, having been founded about the year 627 A.D. The School stands in about 30 acres of ground.

The School-house was rebuilt in 1905. It is lighted with electricity, and supplied with the most modern appliances for sanitation, heating, ventilating, and lavatory purposes. In 1913 a new Boarding House —Clifton Grove—was added, with an additional 8 acres of grounds. A second Boarding House was opened in January, a third in September, 1918, and a fourth in January, 1919.

The School possesses a modern Science Laboratory, a first-class Gymnasium, Fives and Squash Racquets Court, Pavilion and Armoury, Swimming Baths, and a Boathouse on the banks of the River Ouse. It also furnishes a flourishing contingent of the Officers Training Corps.

The School aims at giving a sound general education in accordance with the teaching and principles of the Church of England, with special attention to individual wants. There are no large Forms. The ordinary School subjects include Mathematics, Science, French, Latin, Scripture and English (History, Geography, Composition, etc.), Greek or German, Drawing (Geometrical and Freehand). Boys are specially prepared for Engineering and business life, and for all the Professions.

The Headmaster possesses the right of a nomination to Woolwich, Sandhurst and Cranwell.

The School is well endowed, and many Scholarships and Exhibitions are awarded yearly. A Scholarship Examination is held annually in July.

There is a Preparatory School for boys, where pupils are trained for entry to St. Peter's or other Public Schools.

S. M. TOYNE, M.A., F.R.S.Hist.,
Headmaster.

140

St Peter's School and Chengdu Shishi

This school was founded by St Paulinus of York in the year AD 627 as St Peter's Grammar School along with the Minster Song School, close to where York Minster now stands. An early headmaster, Alcuin (see page 39), went on to be Chancellor to the Emperor Charlemagne, and founded several of the earliest schools in Europe. St Peter's is one of the oldest schools in the world. Chengdu Shishi High School in China (143 BC) is the oldest. St Peter's is the third oldest school in England, after the King's School, Canterbury (AD 597), and The King's School, Rochester (604).

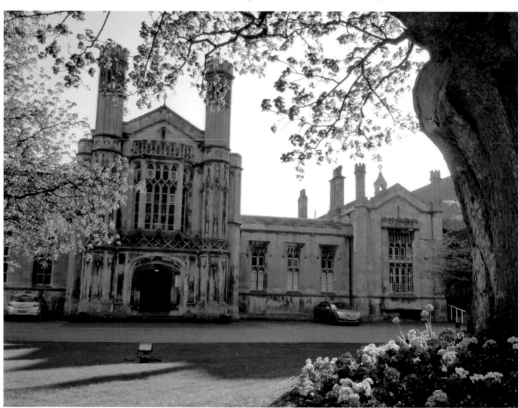

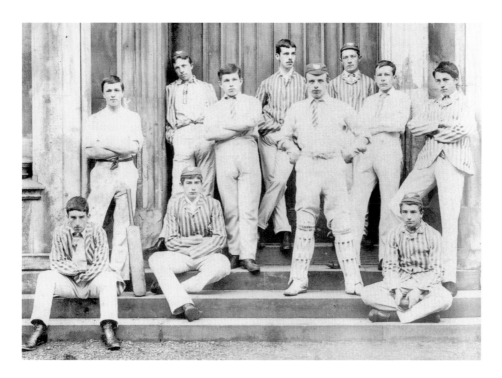

What Links Albert the Wise and Guy Fawkes?

Early teachers and alumni to have attended St Peter's School include St John of Beverley, Egbert (a friend of Bede's), Alcuin and Albert the Wise. Later Old Peterites include Guy Fawkes; Joseph Terry, confectioner; Christopher Hill, Marxist historian; Harry Gration, TV presenter; and John Barry, film score composer of eleven *James Bond* soundtracks, *Midnight Cowboy, Born Free and Out of Africa*. The Harrying of the North saw the destruction of the original school along with much of the city. William I delegated Thomas of Bayeux to rebuild the Minster and the school, which stood where the Minster's nave is today. Cricket old and new is pictured in the photographs; the school's fine tradition has produced such notable cricketers as Frank Mitchell and Norman Yardley.

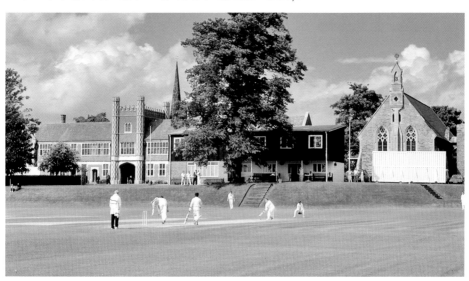

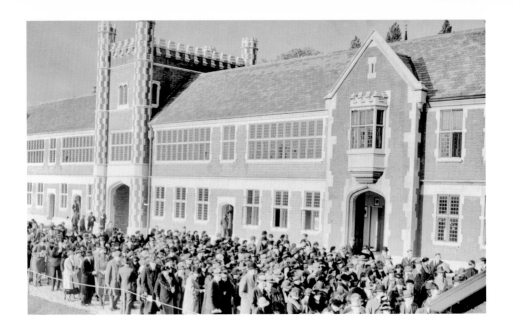

Destruction Follows Calamity

Fifty St Peter's School boarders lived rent-free in the almonry at St Mary's Abbey in return for help with services at the abbey and at St Olave's church. The building of the Minster nave and then the dissolution of the Abbey meant that the school moved again and boarders had to find alternative accommodation: a royal licence allowed St Peter's to take over premises in the Horsefair, near the present-day Lord Mayor's Walk. Calamity followed calamity when the school was destroyed in the English Civil War and the dwindling number of pupils moved to Bedern Hall, followed by five years in the Bagnio, the Turkish baths in Coney Street. In 1736, the school moved to St Andrew's church, and here it remained until 1828. Half of what was first called the 1927 Building had been completed in 1929, but it was renamed Queen's Building in 1953 to mark the coronation. Its opening in 1935 is shown in the older photograph.

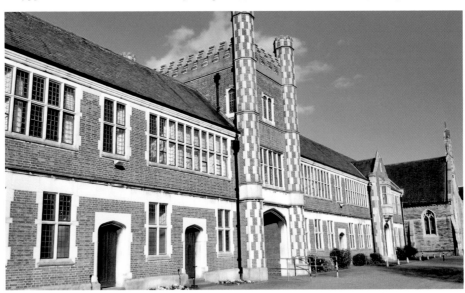

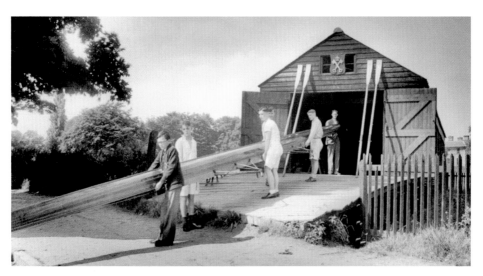

Joining the Proprietary School

St Peter's School's move to a new site – which was later to become the Minster Song School – was followed by an amalgamation in 1844 with the Proprietary School in Clifton. A new school had been built in 1838, ironically on land that Guy Fawkes once owned. The old photograph shows boys bringing a canoe out from the boat house in the 1930s. St Peter's School Boat Club was founded in 1859 and is one of the oldest school rowing clubs in the world; it celebrated its 150th anniversary in 2009.

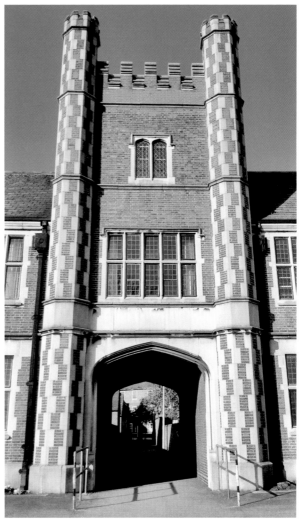

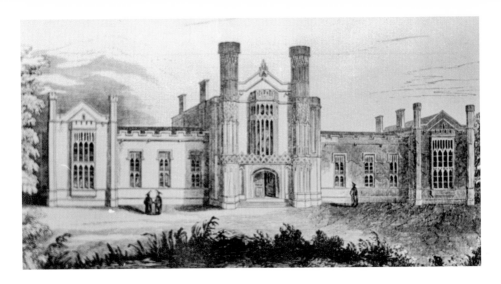

Bonfires without a Guy

St Peter's School does not mark 5 November by burning a Guy on the bonfire, in deference to Guy Fawkes, an Old Peterite. There is, however, a firework display. In 1846, a diet of classical and modern languages, mathematics, geography, history, drawing, dancing, music and drilling was offered. Science subjects were introduced in 1875. The Proprietary School is in the older picture. Below is a 2011 depiction of Guy Fawkes displayed at the Hungate dig – one of twenty-four paintings produced by local community groups working with three Yorkshire artists, Mary Pasari, Cheryl Colley and Lisa Nicholson. The initiative is a partnership between York Archaeological Trust, the Arts and Culture Service at the City of York Council, and Hungate (York) Regeneration Ltd. See also pages 66 and 67.

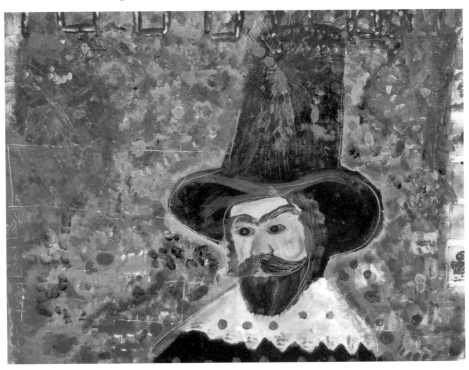

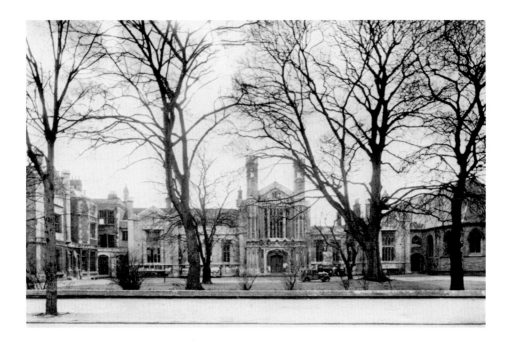

'We Are Not Made of Iron'

In 1856 the Civil and Military Department opened to cater for those pupils destined not for university but for the civil service, the armed services or the law. The school, from its earliest days, nevertheless had a strong track record for sending pupils to Oxbridge; classics awards were particularly frequent and the school featured prominently in the league tables of the day, which were published in the *Pall Mall Gazette*. But it was not all unmitigated success, as these extracts from late nineteenth-century schoolwork show: 'political economy is not going too far in making laws'; 'nous n'irons pas = we are not made of iron'; 'kangaroos are found in Australia and hunted, tinned and exported'; 'Croesus was buried in a wheelbarrow'.

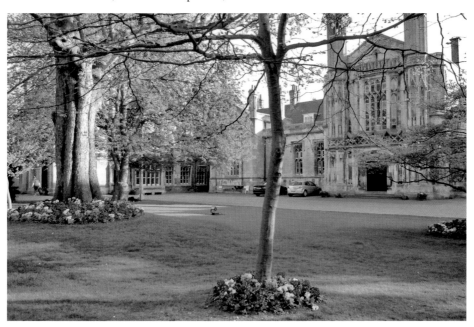

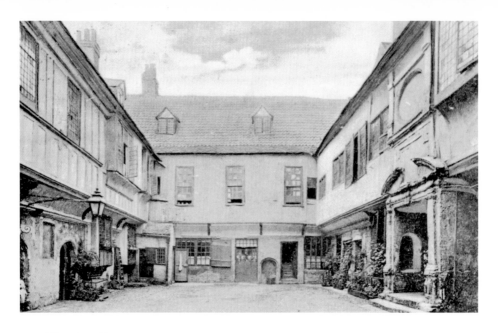

St William's College

Those vicars from Bedern Hall were obviously somewhat particular about the 'common folk' they wanted to avoid (see page 16). However, the priests' reputation for improper behaviour of the carnal variety suggests they did not believe women were that bad. This led to the building of this magnificent college in 1461 – so that the Minster's men could be monitored more closely. Charles I established his printing press here and later occupants included, as at Bedern Hall, insalubrious tenements. Robert Thompson has left his 'mouse mark' on the replacement main doors and today the college serves as the visitors' centre for the Minster.

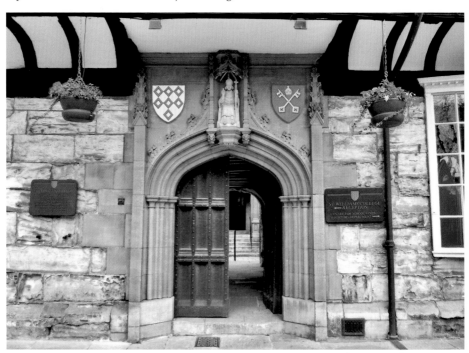

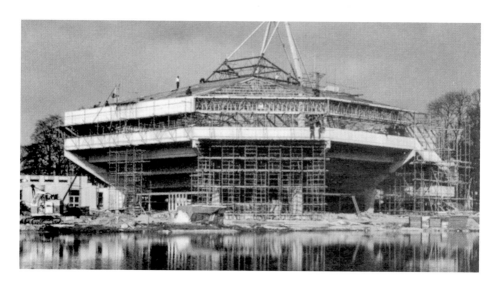

The University of York

Established in 1963 with 200 students and three buildings (Heslington Hall and King's Manor in York city centre are two of them), this collegiate university has now expanded to include a medical school, which it operates with the University of Hull. In 2003 it attracted the highest research income per capita of any UK university. It is among the top twenty universities in Europe, and the top ninety universities in the world, according to the 2010 QS World University Rankings. It was named *The Sunday Times* University of the Year in 2003 and *Times Higher Education* University of the Year in 2010 for its 'success in combining academic excellence with social inclusion, as well as its record in scientific discovery'. *The Times University Guide* said of York that 'the university is increasingly recognised as a permanent fixture in the top rank of British higher education' and that 'no university had a better record for teaching quality'. *The Sunday Times* said, 'York is one of Britain's academic success stories, forging a reputation to rival Oxford and Cambridge in the space of forty years. In teaching it has a recent track record better than Oxford, according to the official assessments of teaching quality.' The photographs show the Central Hall under construction and as it is today.

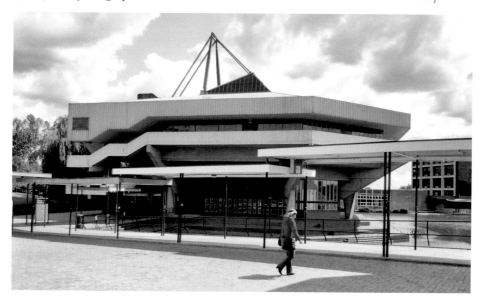

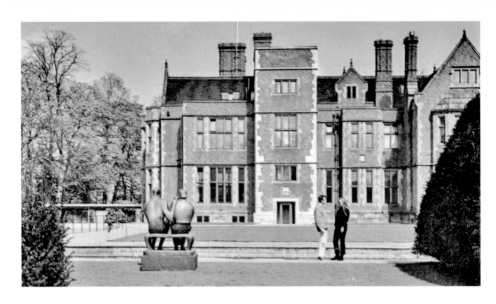

Keep off the Rabbits

The first petition for a university in York was to King James I in 1617. In 1903, F. J. Munby and others (including the Yorkshire Philosophical Society) proposed a 'Victoria University of Yorkshire'. What was then the College of Ripon and York St John considered purchasing Heslington Hall as part of a proposed new campus. The University of York's campus lake is the largest plastic-bottomed lake in Europe and attracts many waterfowl. The campus also supports a large rabbit population, the hunting of which by students is strictly prohibited. Heslington Hall is a fine Elizabethan manor built by Thomas Eymes in 1568; Eymes was secretary to Henry VIII's Great Council of the North, which had its headquarters in King's Manor. As with other buildings of the time, it was constructed in the shape of an 'E' in honour of Queen Elizabeth I. Heslington Hall and the new National Science Learning Centre are shown in the photographs.

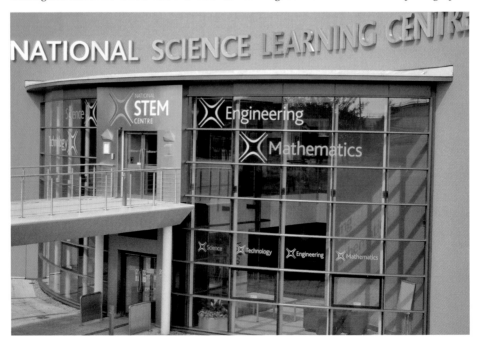

The York Bluecoat School

This school was founded in 1705 as a charity school for forty poor boys by York Corporation in St Anthony's Hall. The blue coats worn by the boys were modelled on the uniform of Christ's Hospital School in Greyfriars, London. A Greycoat School for twenty poor girls was founded at the same time in Marygate, where the girls were trained for a life in domestic service with classes that included wool-spinning. St Anthony's Hall was built between 1446 and 1453 on the site of a chapel of St Anthony for either the Guild of St Martin or the Guild of St Anthony (which was founded in 1446). After the demise of the guilds, it was used between 1627 and 1705 variously as an arsenal, a military hospital and a prison. When the school closed in 1947 it was used by the York Civic Trust and in 1953 housed the Borthwick Institute for Historical Research, now the Borthwick Institute for Archives, at the J. B. Morrell Library at the University of York. The Quilt Museum and Gallery opened in the Hall in 2008 (see page 54). The old photograph shows the memorial to the Blue Coat School on the wall of the hall; the newer one is another exhibit in the Quilt Museum.

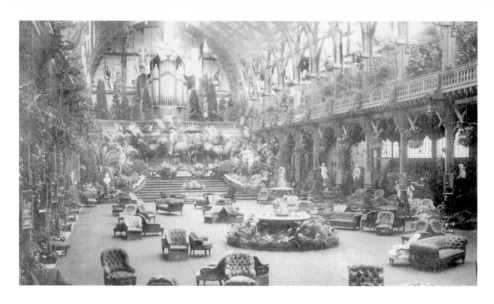

York Art Gallery

The Italianate building that houses the gallery opened its doors to the public in 1879 for the second Yorkshire Fine Art and Industrial Exhibition, inspired by the Great Exhibition of 1851 in London. The exhibition attracted more than half a million visitors and made a profit of £12,000. In 1892 it became the City Art Gallery. The original building had a 'Great Exhibition Hall' at the rear, pictured here. This was a venue for boxing and cock fighting as well as exhibitions; it was damaged by bombs during the Second World War and demolished in 1942. One of the Hungate artworks (see page 60) is below.

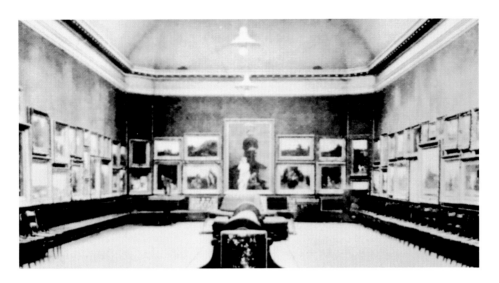

The Evelyn Collection

York Art Gallery's collection was initiated in 1882 when a retired horse dealer from Poppleton, John Burn, was persuaded to leave his paintings to the city rather than to his first choice, the National Gallery. In 1905, Dr W. A. Evelyn held a photographic exhibition in the gallery called York Views and Worthies. In 1934 he presented his extensive collection of photographs of the city to the gallery. A selection of the Evelyn Collection photographs features in a forthcoming book in this series by the author: *In and Around York Through Time*. Two more of the Hungate artworks are shown here and on the previous page. They were produced by five community groups, involving over fifty people. Each group included local artists, adults with mental health issues and learning difficulties, older people in sheltered housing, and homeless people. They worked for three months to create the paintings based around history, people, views from the walls, nature and stonework.

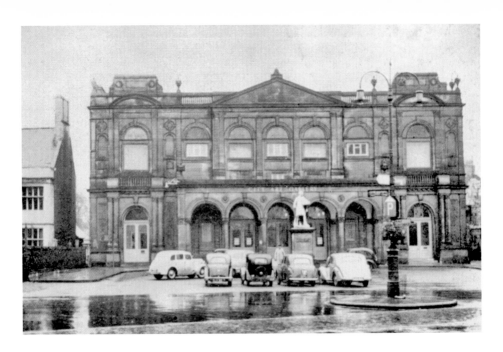

David Hockney and 'the Bigger Picture'

January 2011 saw the exhibition of David Hockney's *Bigger Trees Near Warter*, on loan from the Tate; at 40 by 15 feet it is the artist's largest painting, comprising fifty individual canvas panels. Painted *en plein air* over six weeks, Hockney also used digital technology to create a computer mosaic of the picture, which enabled him to 'step back' and see 'the bigger picture'. Every year between 1950 and 1962 an artist was paid £50 to produce a picture of York: L. S. Lowry's painting of Clifford's Tower is one of the results.

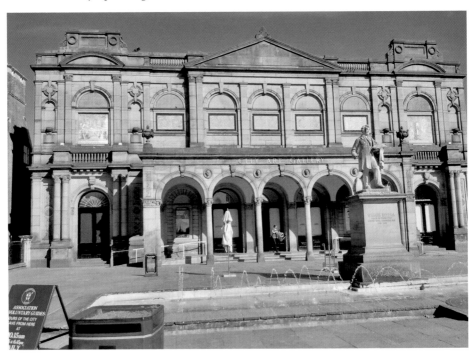

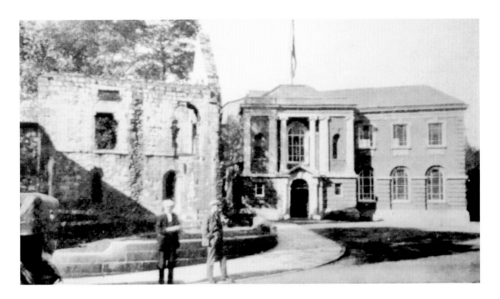

York City Library

The library changed its name in 2010 to the Explore York Library Learning Centre to reflect a wider range of services and research facilities. The local history collection and archives go back 800 years, with over 20,000 books covering the history of York and its surrounding area, as well as local magazines and journals such as the *Yorkshire Archaeological Journal, The Yorkshire Dalesman, Yorkshire Life, the Yorkshire Journal* and *Thoresby Society Publications*. The earliest newspaper in the collection is the *York Courant* of 1728; from this year up to the present, there is a continuous run of indexed newspapers with titles including the *Yorkshire Gazette*, the *York Herald* and the *Yorkshire Evening Press*. Maps and plans show the development of York from the seventeenth century; the earliest map in the collection is John Speed's *Plan of York in 1610*.

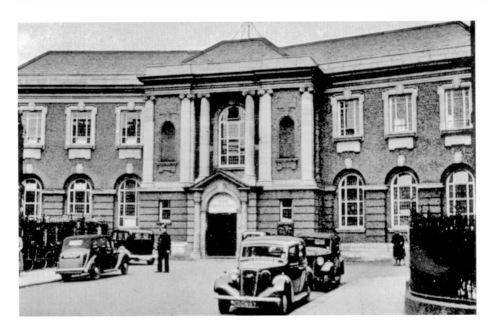

The Library and York Workhouse

The library has poll books for eighteenth- and nineteenth-century York and Yorkshire and electoral registers for the City of York from 1832 until the present day. York Civic Archives start with the Henry II's charter of 1155. The *York Memorandum Book* is the earliest record of council meetings and provides a unique view of life in fourteenth- and fifteenth-century York. There is a record of every single meeting of the city council in a continuous series of 'House Books' and 'Minute Books' from 1746. In addition there are over 12,000 architects' and engineers' plans, dating from the 1850s. The Poor Law collection dates from the 1830s to 1942, and contains records of everyone admitted to the York Workhouse. Most of the letters to and from York artist William Etty are here, as are many of the manuscripts of astronomers John Goodricke and Edward Pigott (see page 52). The modern picture shows the library today, complete with encamped demonstrators protesting about local government spending cuts.

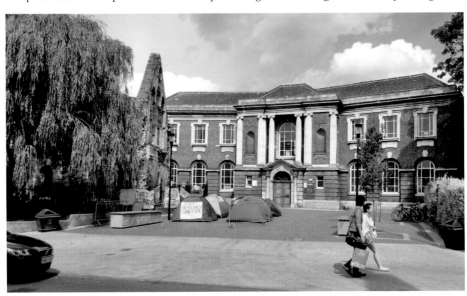

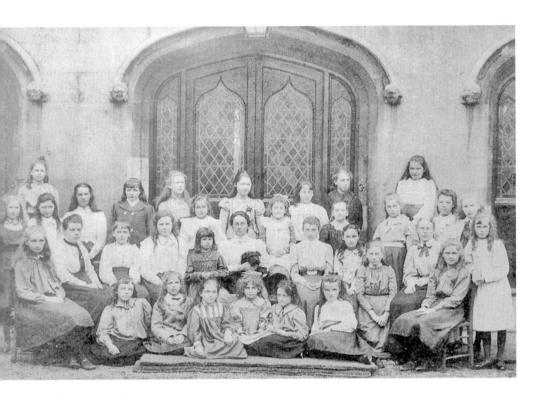

York College for Girls

The college was established in 1908 at 62 High Petergate in a fine building that is, in parts, at least 300 years old. After the school closed in 1997, it remained empty for eight years, then was refurbished and re-opened as a restaurant, La Vecchia Scuola. The spirit of the old school is still very much alive: the owners have a permanent exhibition of many items of school memorabilia to evoke the atmosphere of the school.

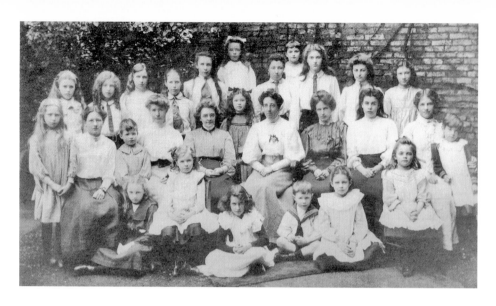

Miss Ellett – E³

The first headmistress of York College for Girls had the nickname E³, thanks to her initials – Elizabeth Emma Ellett. Miss Ellett and her two successors lived in the part of the school that is now Talbot Court; some of the girls boarded in the early days. In 1960, a new building was opened on what was the site of the old Fox Inn, and, before that, in the seventeenth century, the Talbot Inn. This housed the chapel, library, science labs, home economics room and classrooms. In 1981, the school expanded towards King's Square with a music wing, more laboratories and a geography department. The newer picture shows the gardens to the rear of the restaurant.

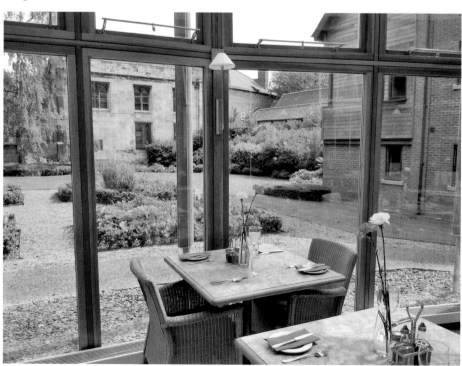

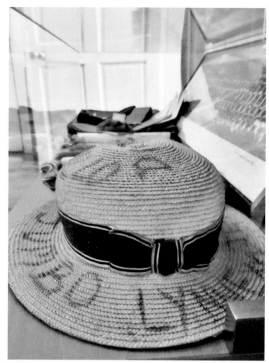

'See Me... in the Bar!'
The bar to the right of the entrance to York College for Girls was the headmistress's study. In the First World War, pupils knitted clothes for soldiers, while during the Second World War, an air-raid shelter stood where the conservatory is now. Former pupils include Dame Janet Baker. The 'old' photograph shows a suitably annotated college boater while the new one is of the bar, once the head's study.

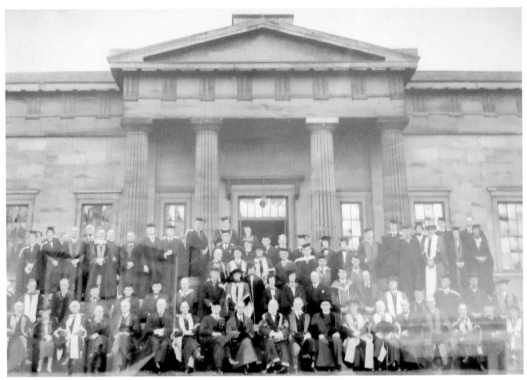

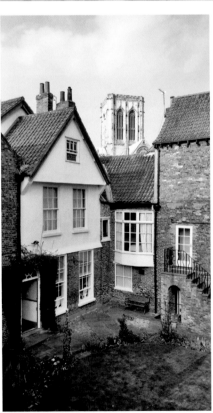

York Medical Society

The society was founded by seven medical men in 1832 for 'the purpose of promoting and diffusing medical knowledge'. This was intended to build on the work of the York Guild of Barber-Surgeons, which had overseen the training and licensing of medical practitioners, standards of treatment and professional education in the city from the fourteenth century. The minutes of the society provide a fascinating record of rapid changes in medicine, diagnosis, epidemiology and social change. The society was active in driving social change and in improving living conditions: a paper from 1842 entitled 'A Plan of Political Medicine' anticipated the ethos and practicalities of the National Health Service by over a hundred years. York's pre-eminence in psychiatric medicine and patient care (as exemplified by the Retreat) is reflected in the society's work. There were also close links with York's first school of medicine, which thrived between 1834 and 1858. Indeed, the annual Oration and other lectures were the main source of postgraduate medical education in the city for many years. The older photograph is of the society's centenary outside the Yorkshire Museum; the newer one is the rear of the society's building off Stonegate today.

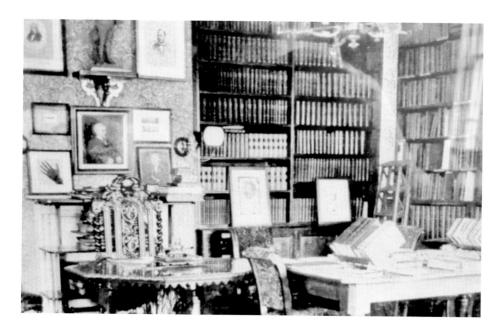

Little Paradise

Much of the timber-framed house used by the York Medical Society goes back to 1590 (as evidenced by the dated lead rainwater head over the entrance doors), although parts such as the wing known as Little Paradise to the left of the entrance and one of the fireplaces are older still. Extensive alterations and additions took place in the seventeenth and eighteenth centuries, including the construction of a second floor, reached by a Georgian staircase. A library was built in an extension and in 1835 another staircase, this time for the right wing, was built by Dr William Anderson. Anderson also bought a house in Grape Lane that had originally been the kitchen wing of what is now Barley Hall; this was added to 23 Stonegate by Anderson. The library, old and new, is shown in the photographs.

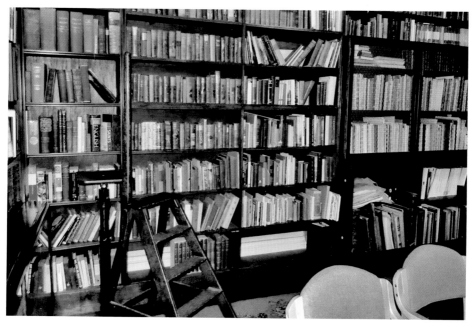

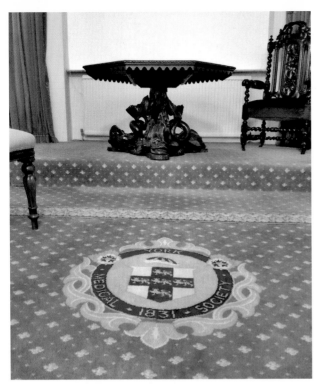

Tempest Anderson's Speaking Tube

A dispensary and consulting rooms were developed by the York Medical Society and the west wing was added by Dr Tempest Anderson (see page 85). It included a large dining room, now the lecture hall. Bedrooms were on the first floor and a ballroom on the second. The speaking tube from Dr Anderson's bed to the front door to address night callers can still be seen. Sales of the properties bought by Anderson's family after his death paid for the wing he bequeathed to the Yorkshire Philosophical Society at the Yorkshire Museum. The York Medical Society began meeting there in 1915 and bought 23 Stonegate in 1944; the Yorkshire Law Society, established in 1786 and the second oldest law society in the UK, set up its library there in 1944. In 1976, the building was extensively restored.

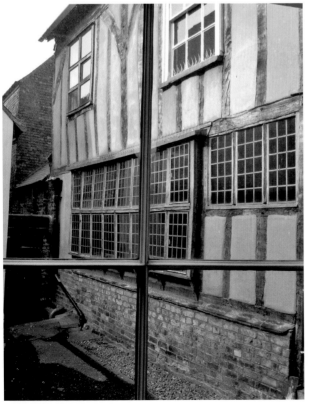

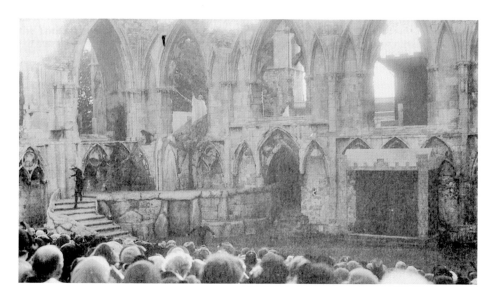

York Mystery Plays

The mystery plays were revived during the 1951 York Festival of the Arts, but they were performed on a fixed stage in the Museum Gardens and it was not until 1954 that a wagon play, *The Flood,* toured the streets. The 1951 production was the most popular Festival of Britain event in the country, with over 26,000 people seeing the plays. The word 'mystery' in this context means a 'trade' or 'craft' in medieval English; it is also, of course, a religious truth or rite. The medieval plays were traditionally sponsored by the city's craft guilds. Nowadays, the medieval Corpus Christi plays are produced every four years by the York guilds and companies. Everything from the Creation to the Last Judgement is paraded through the streets on pageant wagons as actors perform forty-eight key episodes of Christian history at twelve playing stations. The sole surviving manuscript of the York plays, from around 1465, is in the British Library. The pictures show a 1951 performance at St Mary's Abbey and actors preparing for a performance during the 2010 cycle. The 'new' pictures on pages 78–80 were originally published in the limited-edition *The Book of the York Pageant 1909*, published by Ben Johnson & Co., Micklegate, in 1909.

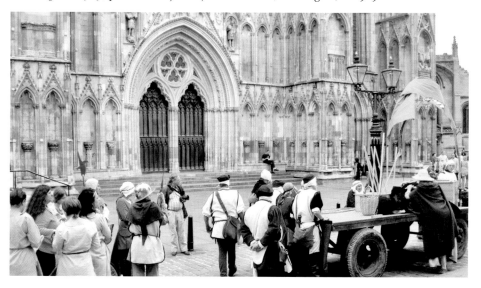

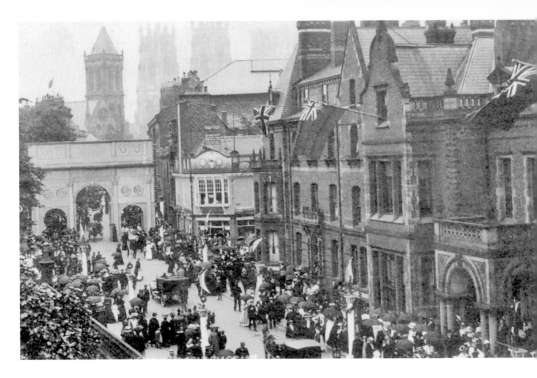

The York Pageant of 1909

The mystery plays were bowdlerised (with scenes involving the Virgin Mary cut) and then completely suppressed in 1569; it wasn't until 1909 that a revival of sorts took place in the guise of the York Historic Pageant, which was performed in and around the Museum Gardens. It included a parade of the banners of the York guilds and a wagon representing the Nativity. Later that year, a selection of six plays was performed as a fund-raising venture for St Olave's church. The pageant was a dramatisation of York's history in seven episodes from 800 BC to AD 1644.

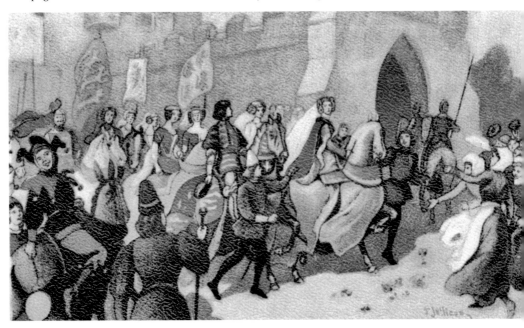

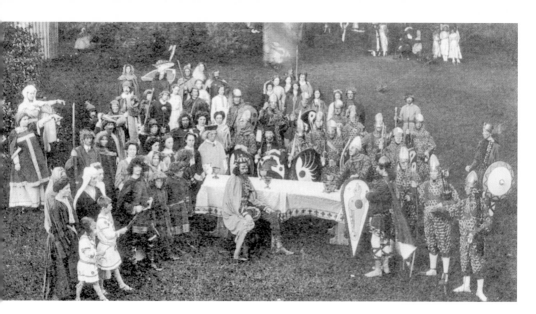

A Cast of Thousands...

The 1909 York Pageant was never intended as a religious ceremony, although it necessarily included religious episodes, as these are inextricably wound up in any 'dramatic representation of the evolution of the old northern capital of Britain'. With a cast of 2,500, the production was truly epic in every respect. For the costumes, 800 designs were submitted by forty different artists and 2,000 tracings were made and coloured. The chorus comprised 220 singers and the music featured the *Carmen Saeculare* and works by Purcell. The substantial plate armour was made by local firm the Eclipse Copper Company. The 'new' image shows Episode 5, Scenes 7–10, with, clockwise from top left: Richard II, Anne of Bohemia, Richard III, Edward IV and Henry IV in the middle.

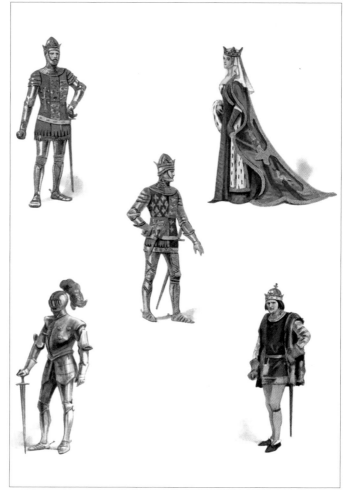

EPISODE VII.

HENRIETTA MARIA COLLECTING VALUABLES FOR THE ROYALIST CAUSE.

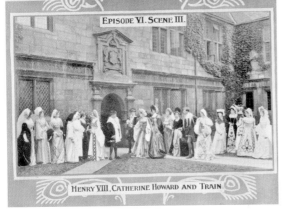

EPISODE VI. SCENE III.

HENRY VIII, CATHERINE HOWARD AND TRAIN.

The Chandler's Pageant

The 1909 York Pageant scene in which the old guilds of York appear is set in 1483, when they were most powerful. *The Chandler's Pageant of the Angels and Shepherds* is adapted from the York Mystery Plays and features twenty guilds chosen to appear before Richard III. Each of these is represented by a master, a brother and a banner-bearer carrying the banner of the guild in question. The guilds represented here are, top from left: milners, curriers. Middle from left: pewterers, skinners, tallow chandlers. Bottom from left: merchant taylors and vintners.

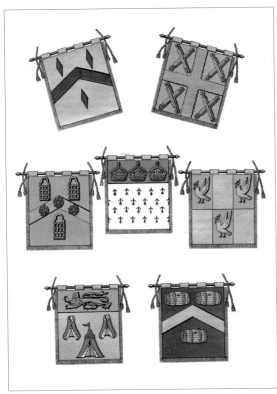

Yorkshire Philosophical Society

The philosophical society was founded in 1822 by four York gentlemen: William Salmond (1769–1838), a retired colonel and amateur geologist; Anthony Thorpe (1759–1829); James Atkinson (1759–1839), a retired surgeon; and William Vernon (1789–1871), son of Archbishop Vernon of York, Vicar of Bishopthorpe. The first three met for the first minuted meeting of the society on 7 December 1822. Their aim was to collect together and house their collections of fossil bones, which had recently been discovered at Kirkdale Cave. Vernon attended the second meeting on 14 December, at which the prospectus was drawn up 'to establish at York, a philosophical society, and to form a scientific library and a museum'. Vernon went on to become president. The society's name comes from the days when 'natural philosopher' was the term for a scientist. The pictures show the society's lodge at the entrance to the Museum Gardens.

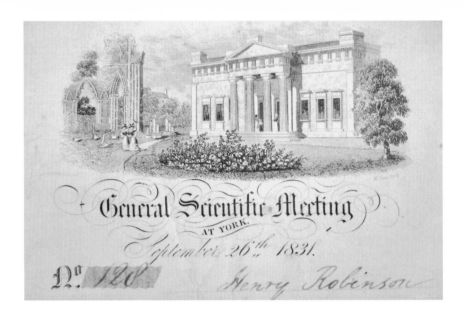

The British Association for the Advancement of Science (I)

The museum was founded by the Yorkshire Philosophical Society to display their geological and archaeological collections. It was in Ousegate until 1828, when the society received, by royal grant, ten acres of land from St Mary's Abbey in order to build a new museum. The main building was designed by William Wilkins in Greek Revival style; it is a Grade I-listed building, and was officially opened in February 1830, making it one of the oldest established museums in England. A condition of the royal grant was that the surrounding land should become a botanical garden. This was completed in the 1830s, and is now the Museum Gardens. Henry Robinson's numbered ticket for the inaugural meeting of the British Association for the Advancement of Science is shown here.

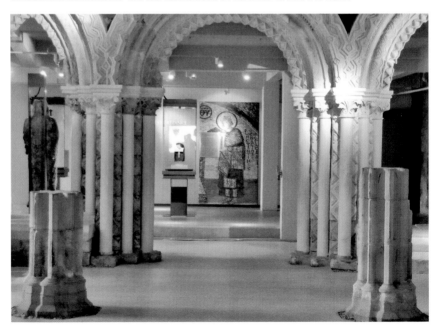

The British Association for the Advancement of Science (II)
Now known as the British Science Association, the British Association for the Advancement of Science was founded with the help of the Yorkshire Philosophical Society and held its inaugural meeting at the Yorkshire Museum in 1831; the poster advertising the jubilee meeting in 1881 is shown here. The astronomical observatory (see page 52) was built in the gardens soon after, extending York's association with astronomy, which began in the 1780s. It is the oldest working observatory in Yorkshire. The Tempest Anderson Hall was added to the museum in 1912, bequeathed by vulcanologist Dr Tempest Anderson to provide facilities for scientific lectures. The new images on pages 82–86 show exhibits from the newly refurbished Yorkshire Museum.

BRITISH ASSOCIATION
For the Advancement of Science.

JUBILEE MEETING IN YORK,
AUGUST 31—SEPTEMBER 8, 1881.
President—Sir JOHN LUBBOCK, Bart., F.R.S., M.P.

GENERAL MEETINGS.
The Meeting will be opened, with the

PRESIDENT'S ADDRESS
In the LARGE HALL of the EXHIBITION, on WEDNESDAY, August 31, at 8 p.m.

On FRIDAY EVENING, Sept. 2, at 8·30 p.m., a Discourse on the RISE & PROGRESS OF PALÆONTOLOGY, by
Prof. HUXLEY, Sec. R.S.,
In the EXHIBITION (Large Hall); and at the same place at 8·30 p.m., on MONDAY EVENING, September 5, a Discourse on the ELECTRIC DISCHARGE, its Forms and its Functions, by

Mr. SPOTTISWOODE, Pres. R.S.

A CONVERSAZIONE
Will be held at the ASSEMBLY ROOMS and CONCERT ROOM, on THURSDAY, September 1, at 8 p.m.; at this the Loan Exhibition of Scientific Apparatus will be shewn.
A CONVERSAZIONE will be held in the EXHIBITION BUILDING on TUESDAY, September 6, at 8 p.m.

SECTIONAL MEETINGS.
These will take place on September 1, 2, 3, 5, 6, beginning at 11 o'clock, at places marked on the Tickets.

MEMBERSHIP :—Life, £10; Annual, £2 the first year, £1 afterwards; Associates' Ticket, £1.
The above are open to Ladies as well as Gentlemen and are not transferable. Tickets for Ladies (transferable to Ladies only) are also issued for £1.
EXCURSIONS will be made on the Afternoons of SATURDAY, September 3, and on THURSDAY, September 8.

There will be an Exhibition of

ELECTRIC LIGHT IN SEVERAL PUBLIC PLACES.
A Lecture to the Operative Classes will be given by

PROFESSOR OSBORNE REYNOLDS, F.R.S.,
On HAILSTONES, RAIN DROPS, and SNOW FLAKES, on SATURDAY EVENING, September 3, in the LARGE HALL of the EXHIBITION BUILDING.

SPECIAL RAILWAY FACILITIES.—Special late trains (at 10·30) to Leeds, Hull, Selby, Harrogate, and Scarbro', and for particulars of which see Advertisements in the Leeds and York papers every day.
Full information can be obtained and Tickets purchased at the Office, 17, Blake Street.
The people of Yorkshire are cordially invited to join the Association by taking Members', Associates' or Ladies' Tickets.

THOS. ADAMS, M.A., } Local Secretaries.
TEMPEST ANDERSON, M.D.

BEN JOHNSON AND COMPANY, PRINTERS, 100 & 101, MICKLEGATE, YORK.

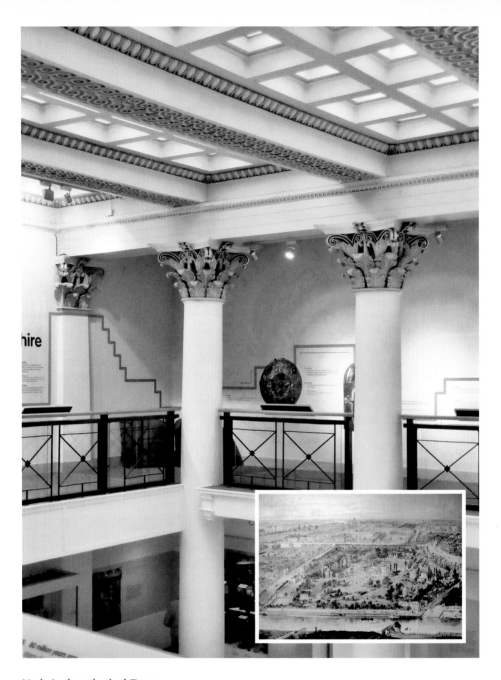

York Archaeological Trust

On 2 January 1961, the Yorkshire Museum and the Museum Gardens were given in trust to York City Council. In 2002, its successor, the City of York Council, set up the York Museums Trust to manage the York Castle Museum, York Art Gallery, the Yorkshire Museum and the Museum Gardens. The Yorkshire Philosophical Society still continues its programme of scientific lectures and works closely with the museum on various projects. In 1971, the society joined the Council for British Archaeology, leading to the formation of the York Archaeological Trust. The older image is of *The Gardens of the Yorkshire Philosophical Society* by John Storey, a colour lithograph now part of the Evelyn Collection in the York City Art Gallery.

Tempest Anderson

An ophthalmic surgeon at York County Hospital, Tempest Anderson (1846–1913) was also an expert amateur photographer and volcanologist. He witnessed the volcanic eruptions in the West Indies in 1902 and 1907. Born in York, he died on board ship on the Red Sea while returning from visiting the volcanoes of Indonesia and the Philippines. He is buried in Suez, Egypt. Tempest was president of the Yorkshire Philosophical Society in 1912, when he presented the society with a 300-seat lecture theatre (the Tempest Anderson Hall, attached to the Yorkshire Museum). Tempest Anderson's photographic collection exceeded 3,000 images, many of which were taken during his travels. The York Helmet (750–75), discovered in York in 1982 by a digger driver, is shown here, on display in the museum.

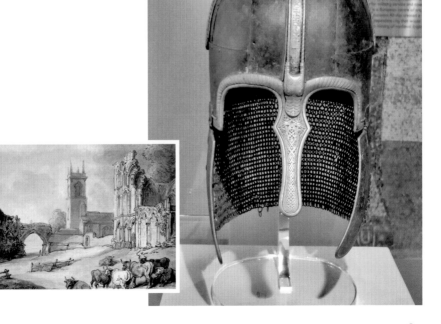

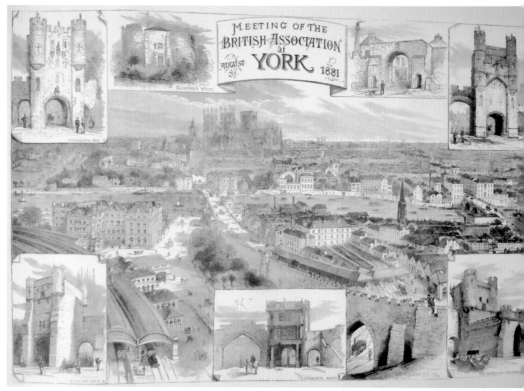

Museum Gardens

The gardens were designed in the 'Gardenesque' style by landscape architect Sir John Murray Naysmith. They are designed to show the Yorkshire Museum and St Mary's Abbey at their best while also providing space for displaying plant specimens in the manner of a botanical garden. As more exotic specimens were introduced, a conservatory was built to house tropical plants such as sugar cane, coffee, tea, ginger and cotton, as well as orchids and epiphytes. A pond was created to accommodate a large, rare water lily, the *Victoria amazonica*. Although the pond and the conservatory are long gone, the 10-acre gardens are still a listed botanical garden and contain many varieties of trees – deciduous and evergreen, native and exotic. Today, the Yorkshire Philosophical Society continues to excite interest in science and archaeology through a series of public lectures, grants, excursions and prizes.

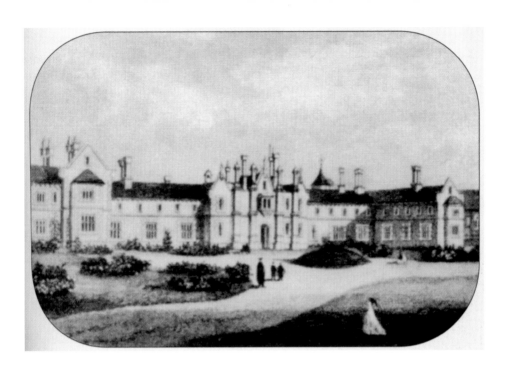

York St John University

The university's roots go back to 1841, when the York Diocesan Training School, for teacher education, opened in May 1841 with one pupil on the register, sixteen-year-old Edward Preston Cordukes. The current students' union building is named after him. The college changed its name to St John's College in the late 1890s. The older picture is of the Diocesan Training School; the newer one shows the university today.

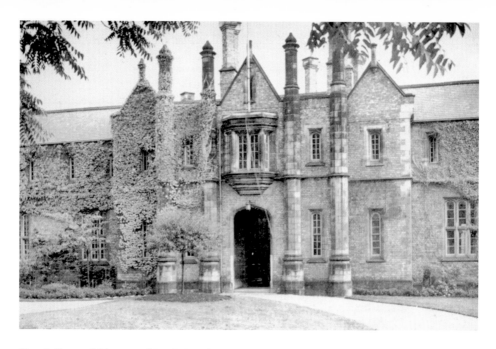

The College of Ripon and York St John

By 1904, St John's was the largest diocesan college in the country with 112 students. In 1974, it merged with a women's college in Ripon to become the College of Ripon and York St John. Since 1920, it has enjoyed connections with the University of Leeds, which validates its research degrees. By 2001 all taught courses had been moved to the York campus and the name York St John was adopted. The college in 1846 is in the old picture; the quad as it is today is in the newer one.

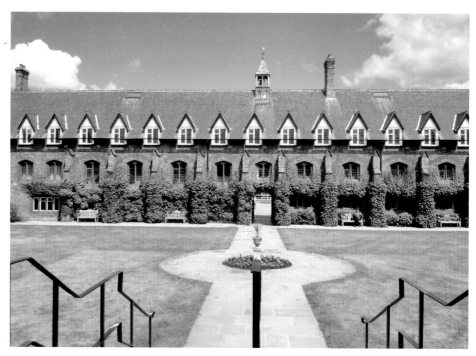

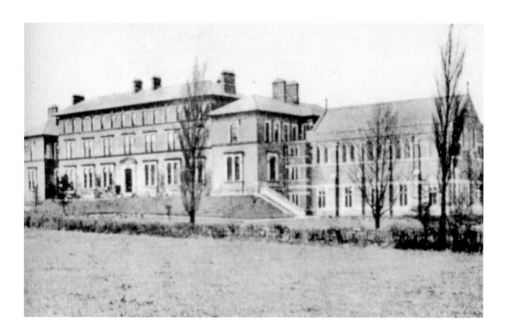

York and Ripon Training College for Schoolmistresses

This college was established in 1846 in Monkgate in premises vacated by St John's College between 1841 and 1845. The students were said to be 'mostly middle-class ... a great portion of time is consumed in instructing them in those elementary branches of learning which belong more properly to a National school than a training institution'. The college moved to Ripon in 1862, as shown in the old photograph. The new photograph and those on page 90 are of the magnificent frieze depicting the development of the college from its beginnings to the present day.

St John's Voluntary Secondary Modern School

The Practising School and the Model School of the York and Ripon Diocesan Training College were opened in 1851 and 1859 respectively on Lord Mayor's Walk. The two schools were complementary, the best teaching methods being illustrated in the Model School for the students to put into practice in the other. A new combined school building was built in 1899.

York Theatre Royal and the City Mint
The first theatre was built on tennis
courts in Minster Yard in 1734 by
Thomas Keregan. In 1744, his widow
built the New Theatre on the site of
what was the city's mint – itself built
on the site of St Leonard's Hospital.
In 1765, it was rebuilt and enlarged
to seat 550; access to the site of the
mint can still be gained from the back
of the main stage. At that time, the
theatre was illegal and it was not until
a royal patent was granted in 1769
that this status changed. The theatre
was renamed the Theatre Royal. Gas
lighting was introduced in 1824 and in
1835 a new frontage was built, facing
onto the newly created St Leonard's
Place. The pictures show a 1938
programme for *The Vagabond King*
and the theatre today.

The Desert Song

York Theatre Royal's stage was rebuilt to include traps and in 1875 substantial renovations included stage boxes, upholstered seats in the dress circle, the construction of the upper circle, the rebuilding of the gallery, the renovation of the proscenium arch and the enlargement of the pit. Five years later, a new Victorian Gothic frontage was added, decorated with carved heads representing Elizabeth I and characters from Shakespeare. In 1888, the area beneath the dress circle was opened out to extend the pit (today's stalls), giving the theatre a capacity of 1400. Two programmes – one from 1957 for *The Desert Song*, the other from 2011 – are shown here.

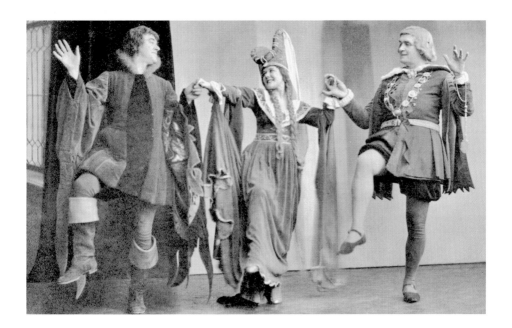

Tabarie, Lady Mary and Oliver

A further reconstruction took place in 1967 with York Theatre Royal's new front-of-house facilities and a staircase in the award-winning concrete-and-glass foyer extension. The old photograph shows Tabarie, Lady Mary and Oliver in a lively scene from the 1938 production of *The Vagabond King*.

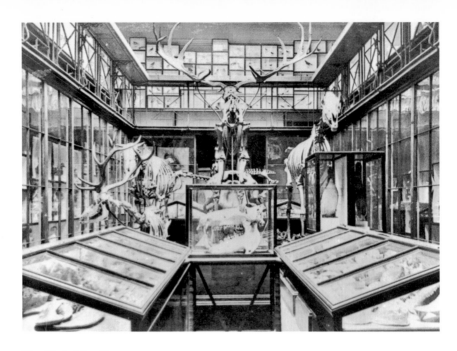

The Yorkshire Museum

The biology collection contains 200,000 specimens, including both fauna and flora. The geology collection has over 112,500 rocks, minerals and fossils. The astronomy collection is mainly in the Observatory in the Museum Gardens, with some telescopes in the Castle Museum. The archaeology collection has nearly a million objects dating from around 500,000 BC to the twentieth century.

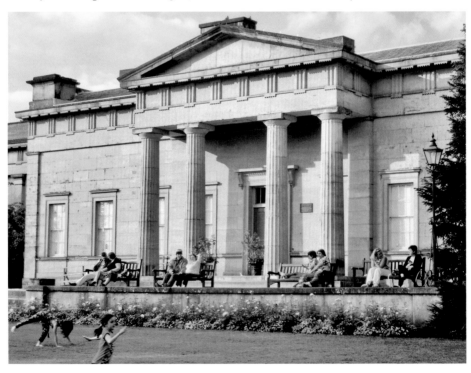

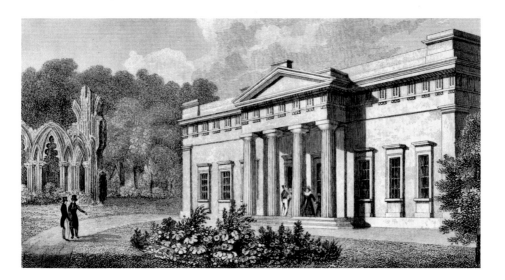

The Prophets

The four permanent collections at the museum have English-designated collection status; they are therefore 'pre-eminent collections of national and international importance'. The new photograph is of the life-size stone saints and prophets painted in gold and other colours. They adorned the west front of the St Mary's Abbey church. They included Moses (nearest to us) with horns, typical of the medieval period due to a mistranslation of the Hebrew Bible into the Latin Vulgate Bible. The Hebrew word taken from *Exodus* can mean either a 'horn' or an 'irradiation' and in this case should be the latter. The most famous horned Moses is Michelangelo's statue in the church of San Pietro in Vincoli, Rome.

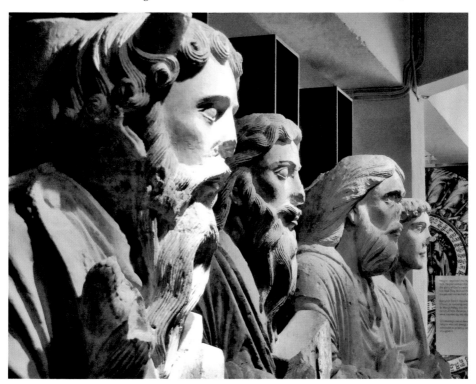

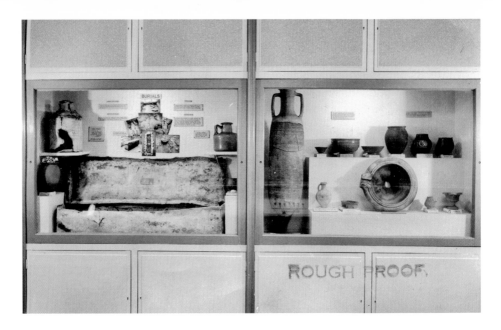

The Roman Collection

In 1992, the Yorkshire Museum paid £2.5 million for the Middleham Jewel (*c.* 1460): a gold, diamond-shaped pendant with a blue sapphire at the top, engraved with a picture of the Christian Trinity on the front and the Nativity of Jesus on the back. The pictures show part of the famous Roman collection. The fourth century AD statue of Mars, the god of war, is on display in the central hall today.

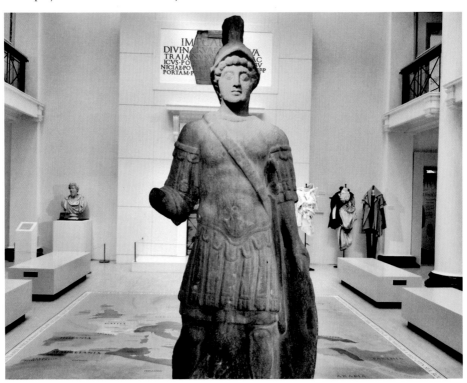